AN AUGUSTA SCRAPBOOK
TWENTIETH-CENTURY
MEMORIES

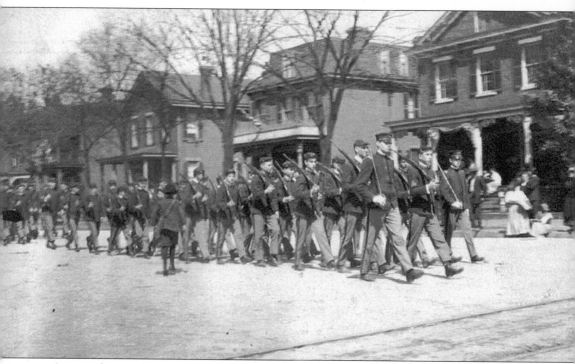

Augusta boasts the longest tradition of high school education in the Deep South with the Academy of Richmond County, founded in 1783. Throughout most of the 19th and half of the 20th centuries, it was exclusively a school for white boys and included a widely recognized Junior Reserve Officers Training Corps program. In the above photo, the Richmond Academy cadets are shown marching in a parade in the 400 block of Greene Street, reminding the citizens of their long and proud tradition. (Courtesy of Augusta Museum of History, M-6.)

Front Cover: This photograph shows an electric trolley car on its way to Summerville. (See page 11 for more information.)
Back Cover: This photo captures bales of cotton against a backdrop of devastation after the fire of 1916. (See page 6 for more information.)

AN AUGUSTA SCRAPBOOK
TWENTIETH-CENTURY MEMORIES

Vicki H. Greene, Scott W. Loehr, and Erick D. Montgomery
Introduction by Dr. Edward J. Cashin

ARCADIA

Published by Arcadia Publishing,
an imprint of Tempus Publishing, Inc.
2 Cumberland Street
Charleston, SC 29401

Printed in Great Britain.

Library of Congress Catalog Card Number: 00-107420

For all general information contact Arcadia Publishing at:
Telephone 843-853-2070
Fax 843-853-0044
E-Mail sales@arcadiapublishing.com

For customer service and orders:
Toll-Free 1-888-313-2665

Visit us on the internet at http://www.arcadiapublishing.com

AUTHORS' NOTE

In the spring of 2000 for a Millennium project sponsored by WJBF Television in Augusta, the general public was encouraged to bring their treasured old photographs to the Augusta Museum of History for scanning. Volunteers and staff from the Museum, Historic Augusta, Inc., and the Richmond County Historical Society were on hand to help the owners of the photographs record the information about each photograph. Documented on a form were the name of the current owner, a description of what the photograph illustrates, names of people shown in the photo, and any other pertinent information that would be useful. Each photograph was scanned into a computer program, and the images were stored on compact disks. The owners of the photos generally waited while this was being done. Two computers were set up in order to make the process run more quickly. Since each photographic image was unique, a unique sequential number was assigned to each one. The numbers for the images recorded on the first computer were assigned a number that began with A, and those recorded on the second computer were assigned a number that began with B. In the editing process, a few additional photographs were added from the collections of the Augusta Museum of History and Historic Augusta, Inc. Those from the Museum are identified by numbers beginning with M, and those from Historic Augusta, Inc. have a number beginning with H. In this way, the photos that appear in this book are keyed to the forms that contain the information recorded from the owners. In many cases, that information was supplemented with additional research to make it as informative and accurate as possible for the reader. Any errors or omissions are not intentional, and the authors would appreciate them being brought to their attention.

Vicki H. Greene
Executive Director
Richmond County
Historical Society

Scott W. Loehr
Executive Director
Augusta Museum
of History

Erick D. Montgomery
Executive Director
Historic Augusta, Inc.

CONTENTS

Introduction 7

1. Transportation 11

2. Downtown 23

3. Entertainment and Leisure 39

4. Schools and Churches 55

5. Savannah River and Augusta Canal 71

6. Businesses and Occupations 87

7. Military 103

8. Residences 113

List of Sources 127

For Further Reading 128

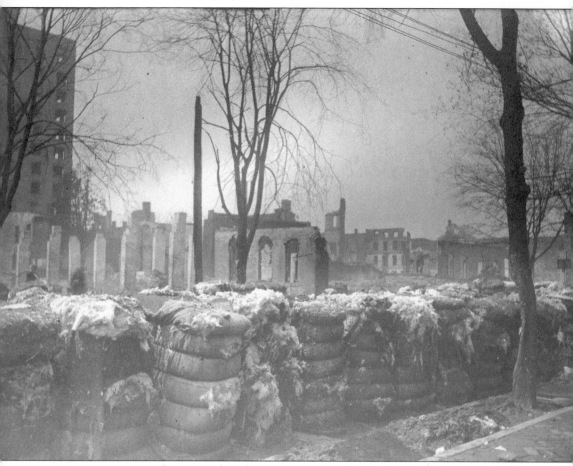

An important part of Augusta's long history centered on a cotton-based economy. Farmers grew it, merchants bought and sold it, it was compressed and warehoused here, and it was made into various goods in a finished form in some of Augusta's mills along the Augusta Canal. The great fire of 1916 can be seen as the dividing line between Augusta's old cotton economy and the beginning of a more diversified industrial base that eventually eclipsed it. This photo shows bales of cotton stacked in the shadow of the ashes that changed Augusta forever. Over the course of the 20th century, Augusta and Richmond County's population would increase almost three times, from 53,735 in 1900 to about 200,000 in 2000, with a five-county metro area of nearly 450,000 people. Out of tragedy comes new opportunity, and this book of old photos gives a visual image of how Augustans lived and prospered over the last century. (Courtesy of Augusta Museum of History, M-5.)

INTRODUCTION

Snapshots. Snapshots are like points from an impressionist's paintbrush. Enough of them make a beautiful picture. This volume is a kaleidoscope of images, a random selection of photographs contributed by individuals from their own personal trove of memories. The publishers of this book are well known for presenting attractive illustrated histories of various cities. Louis Wall of Augusta's Channel Six television station contacted the three local historical organizations to enlist their cooperation in doing a book on Augusta. It was agreed that the focus would be on the collection and publication of new photographs, not those already archived, and that the proceeds would be shared by the three agencies. The call went out for Augustans to bring in their favorite photographs to the Augusta Museum of History, where they were scanned and immediately returned to their owners.

It will surprise no one who has a drawer full of old photographs that once-vivid memories fade with time, and so the reader will notice that not every individual in the photos is identified. This is a source of chagrin to the editors and more so to those anonymously pictured; at least the latter can take comfort in recognizing themselves even if others do not (and perhaps noting their names in their personal copies of this book).

Because the number of pages was set by the publisher, the editors had the difficult job of sorting through the 785 submissions and selecting 204. The editors, Vicki Greene of the Richmond County Historical Society, Erick Montgomery of Historic Augusta, Inc., and Scott Loehr of the Augusta Museum of History, working with the information submitted by the contributors, then wrote the captions.

The result is an Augusta scrapbook, an eclectic assortment of images with memories attached. Our personal histories are like that. We cannot remember all our experiences but we do retain a select few. My first recollections are of the apartment over Dr. Bernard's office on the east side of Thirteenth Street between Broad and Ellis, where I spent the first two years of life (the building is still there). We then moved to the ten hundred block of Telfair Street. I remember sitting under the Atwater Kent radio and listening to Notre Dame games. My father and his friends would go back to the pantry at half-time and drink refreshments out of a brown paper bag. They seemed more animated in the second half.

We moved to Raymond Avenue on the Hill when I was four and then to Craig Street. We played World War in the trenches the WPA dug in Central Avenue. I don't have a mental snapshot of kindergarten, but noticed with surprise a picture of my kindergarten class at Mount

Saint Joseph School in this book. I remember going to the Masters Tournament when the crowds were small in number but too tall for a boy of 12. I glimpsed an opening on the other side of the green and dashed into it, and to my infinite embarrassment, kicked Byron Nelson's ball! I remain grateful to "Lord Byron" for telling the Pinkertons not to cast me bodily into exterior darkness. I liked it when we moved to 1314 Glenn Avenue. I could climb the big poplar tree in our back yard and—if no one was on the water tank on the reservoir—be the highest person in Augusta. The glory of doing something daring was diluted when my younger sister Margie climbed up beside me.

These and more like them are my mental snapshots that substitute for personal history. The collection in this book offers similar glimpses into the lives of others. Very few if any of us had a good grasp of the larger picture, of how we fit into the sweep of history. Only rarely, and then dimly, were we aware that we have been involved in a historically important event. I knew that something mysterious was going on at Daniel Field, where General Jimmy Doolittle's bombers were practicing short take-offs. Later we learned that the daring pilots flew from an aircraft carrier and bombed Tokyo. I knew that World War II must be winding down when I saw hundreds of German prisoners of war sunning themselves behind the Arsenal fence. Only after my college years and return to Augusta did I begin to try to fit the pieces of the puzzle together, and have been at it ever since.

The first 16 years of the 20th century brought mixed blessings. Elsewhere I have called the period the "Ballyhoo Years" because of the boasting by the city fathers that exceeded their achievement. Typical was the construction of the first "skyscraper," the Empire Life Building (now the Lamar Building), which went bankrupt before it was finished. For two winters the entire fleet of Signal Corps air force (six planes) trained here, then moved to a dryer climate in San Diego, California. For a while Augustans fancied their city the movie capital of the country, until the movie-makers packed up and followed the air force to California. The Wright Brothers opened their first flying school here, but it did not last a year. Disappointed at the 1910 census count, the Augusta authorities annexed Summerville, Harrisonville, and Nellieville. After suffering disastrous floods in 1908 and 1912, the city built a massive levee, a project worth boasting about.

The era brought unprecedented legalized segregation. Beginning in 1900, blacks and whites could not sit next to each other on streetcars. In the same year the "white primary" excluded blacks from selecting candidates for the Democratic Party. Gradually, almost every facet of public life was racially segregated. The result was the rise of a mirror-image black professional class of doctors and lawyers. Gwinnett Street (now Laney-Walker) was anchored by Pilgrim Life Insurance Company and the imposing new Tabernacle Baptist Church. President William Howard Taft visited Lucy Laney's Haines Institute, well known for its rigorous curriculum. He returned in 1913 to dedicate the bridge honoring Augusta's Major Archibald Butt, who died bravely on the *Titanic*.

The era ended in an inferno. In 1916, a fire ravaged 32 blocks and destroyed 746 buildings, including some of the city's handsomest residences. Instead of rebuilding in town, many people moved to the Hill. World War I brought another kind of movement to the Hill, as 60,000 soldiers, most of them Pennsylvanians, trained at Camp Hancock. A migration of a different sort was that of black Augustans who moved to Northern cities.

The 1920s were marked by stunts and aerial shows designed to lure customers downtown, and by a real estate boom on the outskirts at Lake Olmstead and Forrest Hills. The fine 1853 plantation house on Fruitland Nursery narrowly escaped demolition by a Florida developer, and instead was transformed into the clubhouse of Bobby Jones's Augusta National Golf Club. Tourists still came to the Partridge Inn and to the Bon Air, but out in the country the boll weevil ruined the cotton crop. The failure of Barrett and Company cotton factors nearly brought down several local banks. The bursting of the levee in 1929 and the simultaneous collapse of the stock market ended the optimism and ushered in a period of malaise and stagnation. The Cracker Party, by means of the white primary, controlled the city and county

governments as well as the board of education and the local judiciary. The New Deal subsidized public housing, road paving, airport improvement, and a new Bell Auditorium.

World War II represents another major transition in our history. War-time installations became permanent fixtures: Camp Gordon grew into Fort Gordon, the Oliver General Hospital became a larger Veterans' Hospital, and Georgia Aero-Tech became Bush Field. The Clark's Hill project grew out of a 1944 flood control bill. The Rolling Fourth Division went off to glory on the battlefields of France. Augusta remembers its own who went off to war at Heroes Overlook on Riverwalk.

Changes accelerated after the war. The end of war-time rationing and fascination with the automobile put people on the highways, so Broad Street merchants began to close their shops and move them to the highways. In the 1950s, Daniel Village and National Hills shopping centers opened and in the 1970s Regency Mall and Augusta Mall continued the trend. The Savannah River "Bomb" Plant was the forerunner of the third great industrialization of this area (the 1845 canal and its enlargement in 1875 caused the first two). Giant factories rose south and east of the city and across the river.

Older institutions transformed themselves—the medical complex sprawled over the old "Frog Hollow" neighborhood and the Junior College of Augusta moved to the abandoned Arsenal grounds and developed into Augusta State University. The Masters Tournament evolved into the grandest golf match in the world. After failing repeatedly to expand its city limits, the city abandoned piecemeal annexation efforts and voters approved consolidation of city and county, catapulting Augusta into the position of the second largest city in Georgia.

A major social adjustment accompanied the dismantling of segregation, beginning with the Supreme Court's ruling against the white primary in 1946. It was a slow process, with the people leading the old-line politicians, and it was not without tragic episodes, particularly the riot of May 1970. At last children representing different races would sit together in a classroom and listen to a teacher tell about the meaning of the words in the Declaration of Independence.

If building the levee was Augusta's proudest feat early in the century, the breaching of it was of equal importance in the latter part of the century. Augustans marvelled at the rediscovery of the river, enjoyed the historic walk along the Riverwalk esplanade, and gathered for celebrations at the amphitheater named for the "grande dame" of the opera, Augusta's Jessye Norman. Ranking with the return to the river is a renewed appreciation for the past. Historic preservation was slow in coming. The city preserved Colonel George W. Rains' Powderworks Chimney, the Daughters of the Revolution saved George Walton's Meadow Garden, and the Garden Club restored the Old Medical College building. But the grassroots' impulse to preserve came with the tearings down of progress. The Richmond County Historical Society intervened in 1948 to maintain the 1797 Ezekiel Harris House (though they thought it was an even older building). Concerned citizens organized Historic Augusta, Inc. in 1965 to preserve the Old Government House and its Telfair Street neighborhood. Peter Knox initiated a restoration of Victorian "Olde Towne" and restored the architectural masterpiece that is Sacred Heart Cultural Center. The Augusta Canal Authority was formed to insure the preservation and public uses of the historic canal. The dynamic Augusta Genealogical Society moved into a Beaux Arts bank building on upper Broad Street. Augustans did not care for the noted architect I.M. Pei's Chamber of Commerce in the middle of Broad Street, but approved of the restoration of the original facades of the stores on the street. Many were surprised to learn that Augusta is and has been home to the oldest African-American congregation in the entire country, Springfield Baptist Church.

At the turn of the century exciting things are happening downtown, even as the outskirts grow apace. Thanks to Clay Boardman, the long-vacant Enterprise Mill has been adapted for living and office space. A park has been designed to commemorate the history of Springfield Church and its neighborhood. Historic Augusta, Inc. has raised nearly two million dollars to restore Woodrow Wilson's boyhood residence and the adjacent Joseph R. Lamar home. The Morris Museum of Art is the unique depository of a fine collection of Southern art; the Golf

Hall of Fame is nearing completion; the National Science Center's Fort Discovery is attracting thousands; and the Augusta Museum of History is engaged in a major expansion drive.

None of these ambitious projects would be possible without the active support of the people of the community. In this scrapbook, the Richmond County Historical Society, Historic Augusta, Inc., and the Augusta Museum of History have provided a means for hundreds of ordinary people to be memorialized. It is a nice way of saying thanks to those who appreciate the past.

Edward J. Cashin
Augusta State University

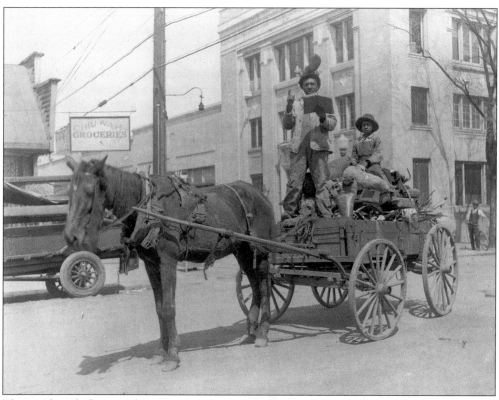

This unidentified man, who appears to be preaching, was photographed at the intersection of Gwinnett (present-day Laney-Walker Boulevard) and Ninth Streets, c. 1925. The area was known as the "Golden Blocks," and this intersection marked the center of black social, cultural, business, and religious activities for decades. Within a small radius of this hub were located the Penny Savings and Loan Investment Company (building pictured in background), the Pilgrim Health and Life Insurance Company, Haines Normal and Industrial Institute, the Lenox Theater, and Tabernacle Baptist Church. Some Chinese who remained in Augusta following their work on the Augusta Canal opened grocery stores catering to black clientele. More than 30 Chinese-operated grocery stores were located in the black business and residential sections. This integration pattern continued for several decades. (Courtesy of Augusta Museum of History, M-4.)

One
TRANSPORTATION

The 20th century has seen more revolutionary change in modes of transportation than any other. The photos that follow show how Augustans learned to travel, by train, by trolley, by automobile, and by air. It also shows how the improvement of one type of transportation may have eclipsed another, dooming it to virtual extinction. Today, our modes of transportation affect everything that we do, and as the century closes, among the biggest issues of our city are improving streets and connecting highways, increasing air traffic to our airport, and solving the problem of freight trains that still lumber through the center of town.

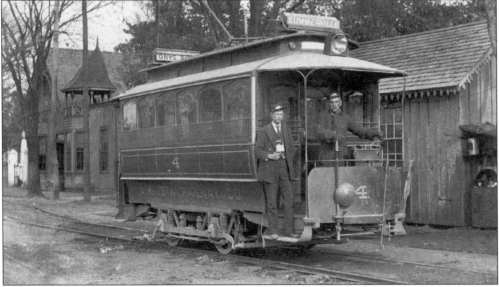

By the turn of the 20th century, Augusta had been using electric trolley cars for 10 years, since Colonel D.B. Dyer came to town and converted the original horse-drawn ones to electric power. Like trains, trolleys were operated by conductors, and this was the role that the two gentlemen in the photo played. The one on the step is Mathison Haywood Weathersbee, and the other is unidentified. (Courtesy of Adis Olson, B-79.)

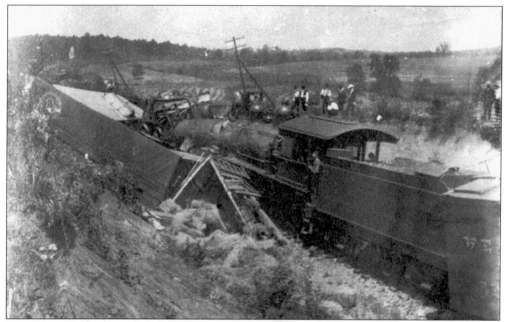

Two engines collided on the Georgia Railroad in 1907, a time when railroads were still the fastest and best form of transportation. Perhaps the trains were traveling too fast, resulting in this unfortunate accident near Augusta. (Courtesy of Anne Lane, A-195.)

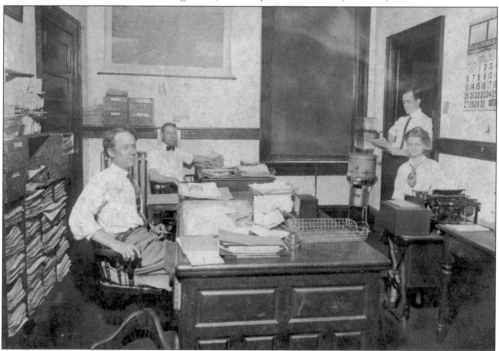

Working for the railroad was a good, stable job in the early 20th century. These railroad employees operated the claims office of the Georgia-Florida Railroad in this photo taken c. 1913. The gentleman in the foreground is John L. de Treville. (Courtesy of Virginia E. de Treville, A-135.)

Three of Augusta's trolley car operators posed in the early 20th century with a stuffed alligator, perhaps alluding to the mild climate that attracted winter visitors to the area. The electric trolleys made it easier to get from downtown to Summerville, where the tourist hotels and boarding houses were located. The trolley line made a large loop around downtown and then went up Walton Way through Summerville. (Courtesy of John H. Lotz, A-91.)

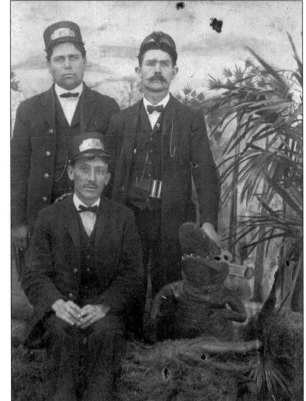

Horseless carriages began to replace buggies and surreys on the streets of Augusta in the first decade of the 20th century. This model was displayed on the old fairgrounds in Augusta. (Courtesy of Joan McCullough, A-359.)

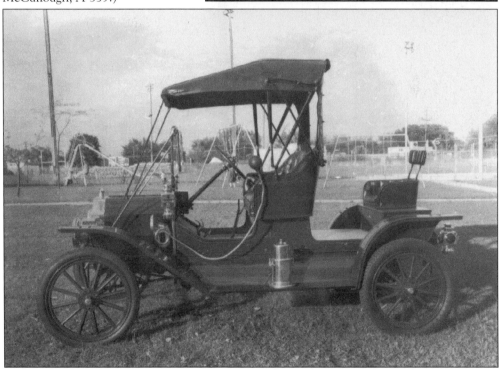

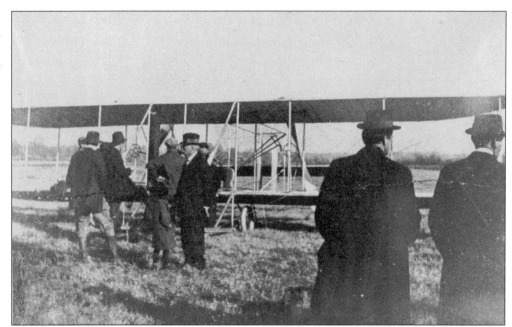

Aviation was introduced to Augusta in 1910 when a flight school was established on Wrightsboro Road. Later, the Wright Brothers started another flight school on Sand Bar Ferry Road. This photo at Christmastime in 1915 shows one of the very early planes in Augusta. The elderly gentleman is Theodore Pruden. (Courtesy of Virginia E. de Treville, A-134.)

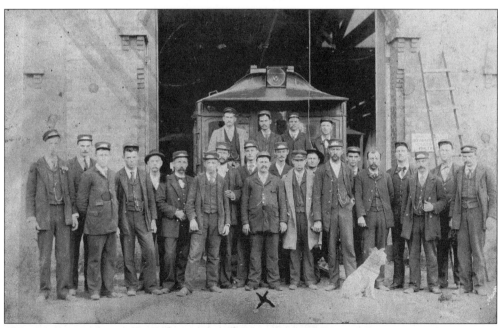

The Augusta-Summerville Railway operated Augusta's trolleys. Numerous employees were required to operate the system. Another line, known as the Interurban, connected downtown Augusta with North Augusta, the towns in the Horse Creek Valley, and Aiken. (Courtesy of Robert L. Thompson, B-246.)

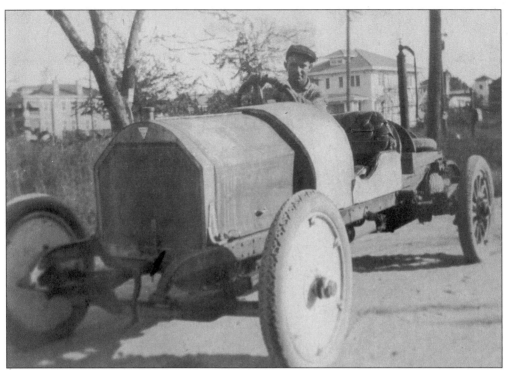

In the early days of the automobile, at least one Augustan made his own model. In this *c.* 1918 photo, Mr. Reuben Auburn Holliday shows off the car he built from scratch and drove for many years. An unusual feature was the set of wooden tires that never went flat. This photo was taken on Greene Street in downtown Augusta. (Courtesy of Phyllis C. Holliday, A-182.)

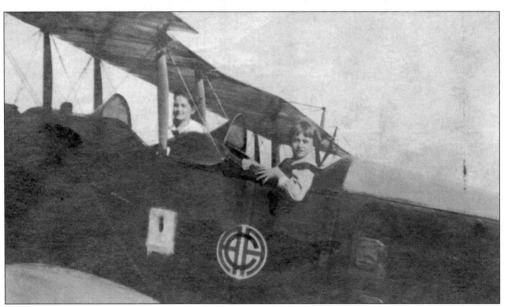

Daniel Field was originally a part of Camp Hancock when this *c.* 1920 photo was taken. Aspiring pilots Claud Caldwell and Larkin Mulherin manned this World War I–era airplane. (Courtesy of Claud R. Caldwell, A-241.)

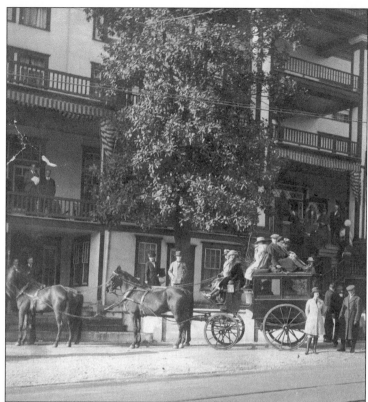

Even though electric trolleys, automobiles, and airplanes were rapidly replacing horse-drawn conveyances in the early 20th century, both practicality and nostalgia kept them in use for the tourist hotels. This c. 1920 photo shows a stagecoach loaded with passengers in front of the Partridge Inn on Walton Way, and appears to be taking guests on an excursion. (Courtesy of Joseph M. Lee III, B-170.)

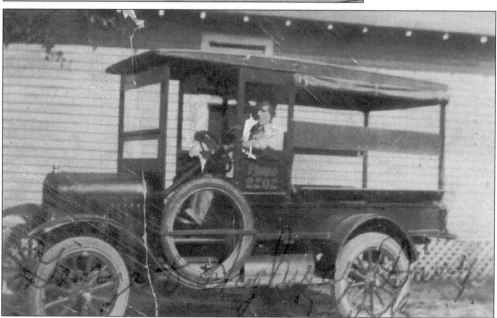

Besides automobiles and ambulances, another early form of motorized vehicle in Augusta was the dairy truck used to deliver fresh milk, cheese, and other products to area homes. This 1920s photo, taken at a house on Milledgeville Road, shows George Alexander Adams sitting in a Hughes Dairy Truck. (Courtesy of Marie Kuhlke Ritch, A-160.)

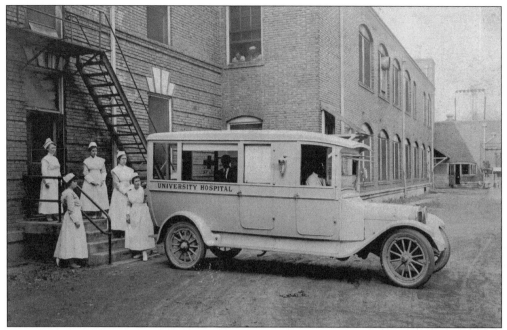

University Hospital purchased an ambulance about 1920 to meet the need for fast transport of seriously ill patients. The emergency room nurses are seen at the door of the old hospital, located on University Place between Harper and Gwinnett Streets. University Place is now R.A. Dent Boulevard, and Gwinnett Street is now Laney-Walker Boulevard. (Courtesy of Mary O. McClain, B-344.)

Other modes of transportation became more popular in 20th-century Augusta, but the railroads had many years to reign as the preferred way to get to out-of-town destinations. The Union Passenger Station, pictured in the background, was constructed in 1902. This *c.* 1930 photo shows William H. Woodruff and Lloyd Cone posing on the fountain in Barrett Plaza, a park in front of the station. (Courtesy of Louise Woodruff, B-235.)

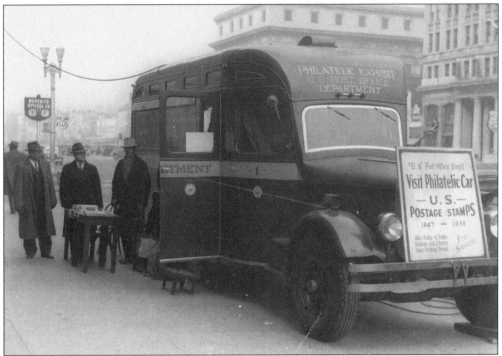

In 1938, the U.S. Post Office Department sponsored a "Philatelic Car" around the country to encourage stamp collecting. Here it is shown in the 700 block of Broad Street with the Dyer and Lamar buildings in the background. (Courtesy of Louis F. Servant, A-60.)

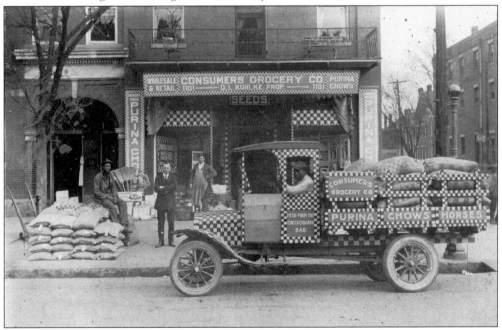

Consumers Grocery Company at 1101 Broad Street sold feed and seed, and delivered in this truck in the 1920s. Dessey L. Kuhlke, the owner, is the gentleman with his arms folded and standing on the sidewalk. (Courtesy of Marie Kuhlke Ritch, A-156.)

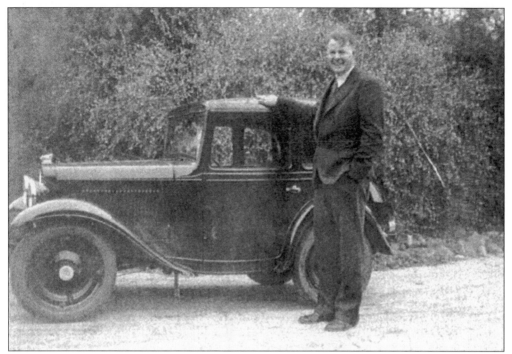

Compact cars were not an invention of the late 20th century, as evidenced by this *c.* 1935 photo of Gwinn Nixon with his American Austin automobile. The two-seater once made a journey to Tybee Island from Augusta with Mr. Nixon's small daughters, Sally and Eleanora, sitting on a board behind the driver's seat. (Courtesy of Eleanora Hoernle, B-133.)

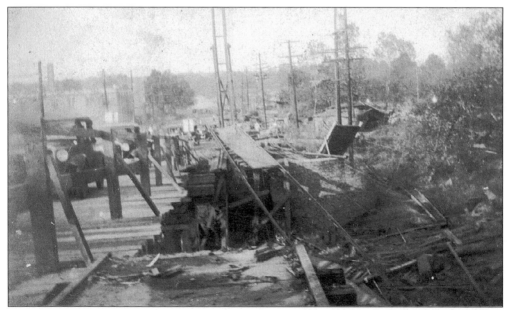

The rapid rise in popularity and use of motorized vehicles in the 20th century led to the improvement and paving of many new highways. Shown here is the paving of Milledgeville Road at the intersection of Olive Road before 1940. (Courtesy of Jodi Lowe, A-322.)

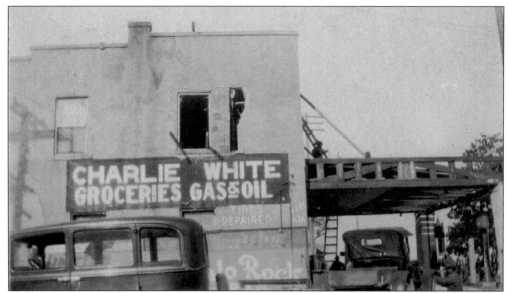

The need for service stations arose with the increasing number of roads linking neighboring towns and the ever-gaining use of the automobile. Charlie White Groceries, Gas, and Oil was located at the intersection of Milledgeville Road and Olive Road as shown in this c. 1940 photo. Drive-in convenience stores had arrived in Augusta. (Courtesy of Jodi Lowe, A-320.)

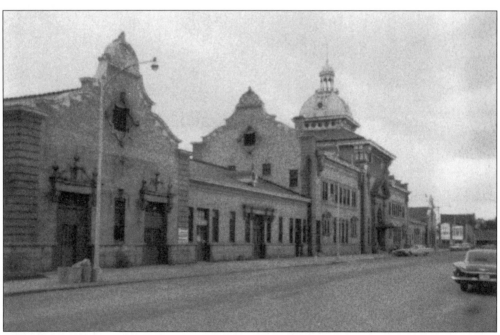

The Beaux-Arts style Union Passenger Station had fallen into less and less usage with the transfer of the traveling public's affections from rail to automobile and air. The last regularly scheduled passenger train left Augusta in 1968, and the station was demolished in 1972. (Courtesy of Virginia E. de Treville, A-137.)

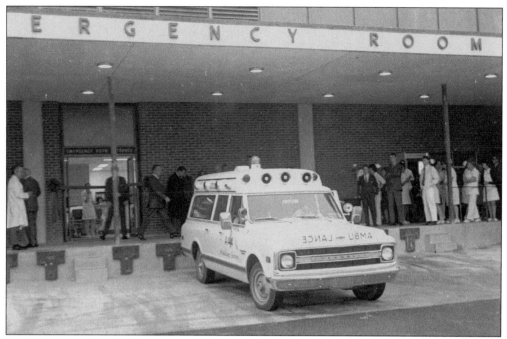

Transport of critically ill patients had come a long way by the time this photo was taken in December 1970. This "hightop" ambulance was backed up to the new University Hospital Emergency Room in preparation for unloading a patient. (Courtesy of Tom Schneider, B-310.)

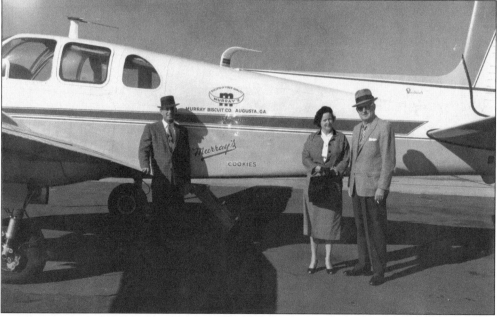

Some of Augusta's major businesses used Daniel Field as their home base for private planes after 1949, when Bush Field became the main commercial airport. John L. Murray Sr. (right) of Murray Biscuit Company is shown here in 1960 with his first plane. Pictured with Mr. Murray are his wife, Mrs. Nolia Murray (center), and the pilot, Gordon Jordan (left). (Courtesy of Larry J. Murray, A-97.)

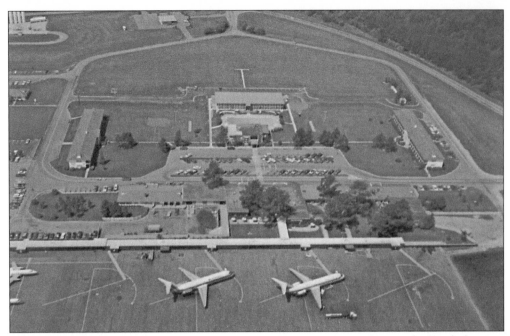

Bush Field, a World War II–era military installation on New Savannah Road, became Augusta's main commercial airport in 1949. This 1960s aerial view shows the symmetrical plan of the terminal and its extensive grounds. (Courtesy of Annette Dobyne, B-101.)

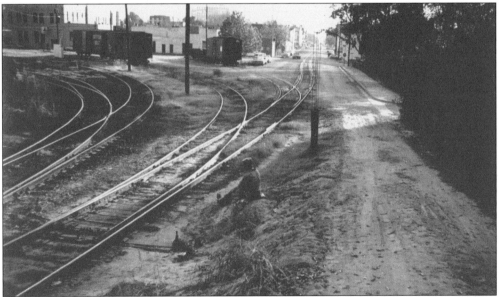

Although passenger railroads had diminished in importance to Augustans by the late 20th century, freight trains continued with regularity through downtown. This 1976 photo shows the tracks that run down the middle of Sixth Street, and a spur that curved over to the old Southern Railroad depot in the 500 block of Reynolds Street. This view looking south down Sixth Street was taken before Riverwalk was built on the levee along the Savannah River. Just out of sight to the right is Saint Paul's Episcopal Church, and straight ahead to the left is the present site of the Augusta Museum of History. (Courtesy of Charles Watkins, A-83.)

Two

DOWNTOWN

Downtown Augusta is one of the most intriguing areas of the city, where more of our collective history is concentrated than in any other part of town. Not only have we worked and shopped there, but many have lived there, both above the stores and tucked in-between commercial buildings. Because of the dense nature of the downtown district, Augusta's periodic floods and fires have wreaked more havoc in downtown than in other neighborhoods. Every Augustan more than 30 years of age at the close of the 20th century can remember when downtown was the economic and cultural hub of the entire region. Those born later have led the way in pioneering the revitalization of a long-neglected historic trove of architectural and historical gifts from the past. The photos that follow give us a glimpse of the past 100 years, as downtown Augusta has evolved from a vibrant mecca for all people in the community, to desperate decline following suburban sprawl and commercialization, and then revived by reclaiming its historic buildings and encouraging entrepreneurial ventures and downtown living once again.

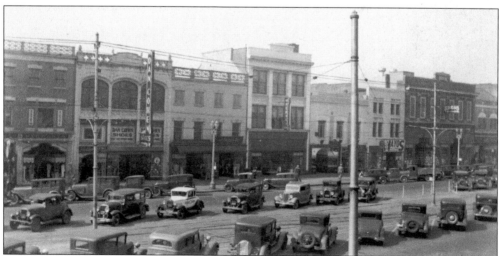

For the first 80 years of the 20th century, downtown Augusta was the unrivaled center of commerce in the Central Savannah River Area. This c. 1930 photo, taken by William F. Bowe Jr., shows the south side of the 800 block of Broad Street, with cars lining both sides and the middle of the street. Notice the trolley tracks and electrical lines for the trolleys hanging above. (Courtesy of Virginia Bowe Strickland, A-213.)

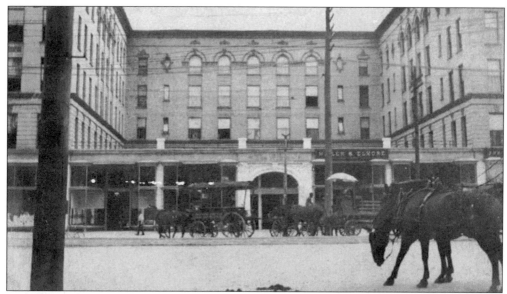

Long before Summerville became a winter resort near Augusta in the late 19th century, downtown Augusta had numerous hotels that catered to different needs and different tastes. The Albion Hotel, located at 738 Broad Street, was constructed c. 1900 and included various stores along the street. It burned in 1921, and was not rebuilt. The center portion was made into Albion Alley, connecting Broad and Ellis Streets, and the eastern portion, which survived, was used for many years as the downtown J.C. Penney Company. The western portion was cleared away after the fire. In its place the eight-story Richmond Hotel was built, which is still standing. (Courtesy of Anne Lane, A-176.)

Another landmark in downtown that was lost during the 20th century was the City Hospital, located behind the Old Medical College building at the northeast corner of Walker and Sixth Streets. Built in 1869, this hospital served the city's medical needs until it was replaced by University Hospital in 1915. (Courtesy of Anne Lane, A-167.)

The Augusta Cotton Exchange has survived the 20th century despite the massive destruction of the cotton economy caused by the boll weevil in the early decades. Built in 1886 at 32 Eighth Street on the northeast corner of Reynolds, it continued in its original use until 1964. In 1990 it was restored by William Moore, and rented to the Convention and Visitors Bureau as a visitors center. A cotton museum was developed for the first floor, which is enjoyed by visitors seeking tourist information about the city. (Courtesy of Anne Lane, A-166.)

This c. 1900 photo identifies the Love and Norville Building on the right, still standing today at 1162–1168 Broad Street. Its sign in the cornice declares it to be the Brislan Building, 1896. The building next door at 1154–1160 Broad Street still stands too. These were typical of the multi-use commercial buildings still being constructed on upper Broad at the turn of the 20th century. (Courtesy of Roberta Reinert, A-59.)

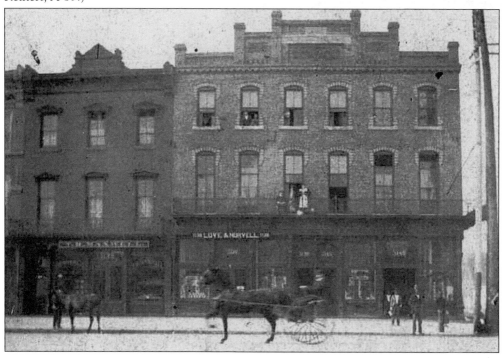

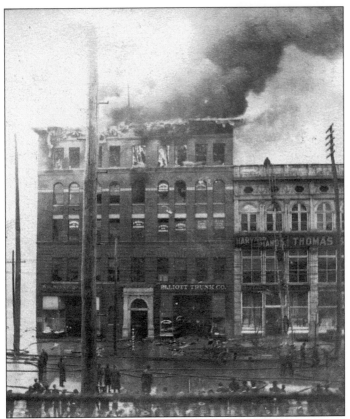

The *c.* 1899 Leonard Building, boasting five stories, was an early high-rise in downtown Augusta. Located at 700 Broad Street, it went up in flames in February of 1906. It was subsequently repaired, and continues to serve as an office building, with a bank on its first floor. (Courtesy of Anne Lane, A-170.)

The Odd Fellows Hall, at the southwest corner of Eighth and Ellis Streets, is shown here in 1908. Built in 1870 for the Independent Order of the Odd Fellows, a fraternal order, it also housed the Augusta post office at the time. It was renovated in 1994, with apartments on its upper floors. (Courtesy of Anne Lane, A-107.)

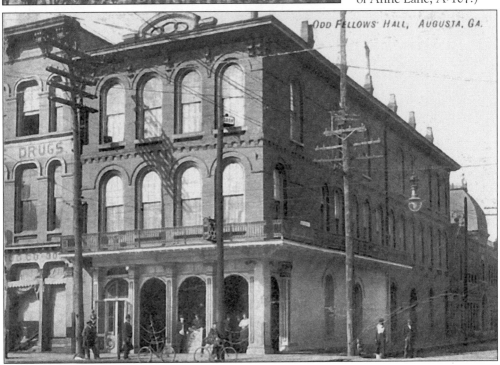

A larger post office was built in Augusta in 1889 at the southwest corner of Ninth and Greene Streets. Following the completion of another Federal Building on Barrett Plaza, this structure was converted into city hall in 1918. It was razed in 1959 to erect the present Augusta Public Library. (Courtesy of Anne Lane, A-168.)

This January 1920 photo shows the general offices of the Georgia Railroad in flames. Located at 611 Eighth Street, it was built in the 1890s on the edge of the rail yards. (Courtesy of Don Boykin, A-101.)

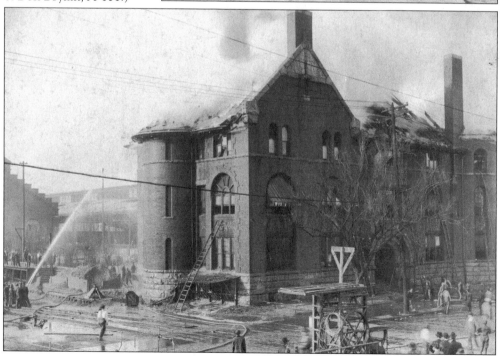

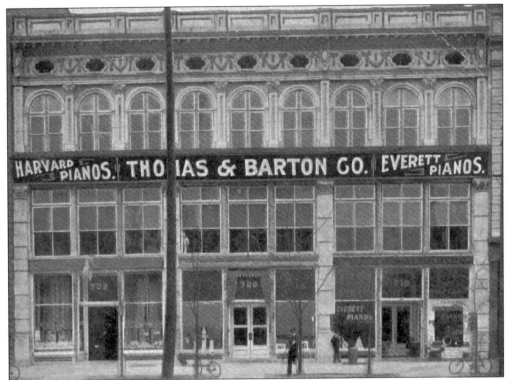

Thomas & Barton Company, located at 710 Broad Street, specialized in musical merchandise, furniture, bicycles, and sewing machines. From the sign it appears obvious that Harvard and Everett pianos were the most important item for sale. (Courtesy of Anne Lane, A-109.)

This aerial view shows Broad Street from the top of the Dyer Building, at Eighth and Broad, looking west. This photo was taken before 1916, when the great fire started in the basement of the Dyer Building. (Courtesy of Anne Lane, A-178.)

This aerial view of Eighth Street looking south from the top of the Dyer Building, at the corner of Eighth and Broad, was taken prior to the 1916 fire. (Courtesy of Anne Lane, A-183.)

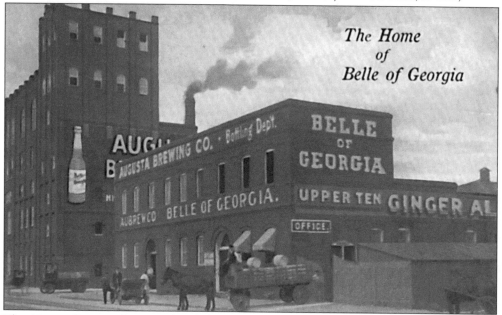

The Augusta Brewing Company bottled Belle of Georgia beer and Upper Ten soft drinks on the west side of Thirteenth Street between Fenwick and Nelson. This 1916 view shows the extent of the operation, which was owned by William A. Herman. (Courtesy of Anne Lane, A-104.)

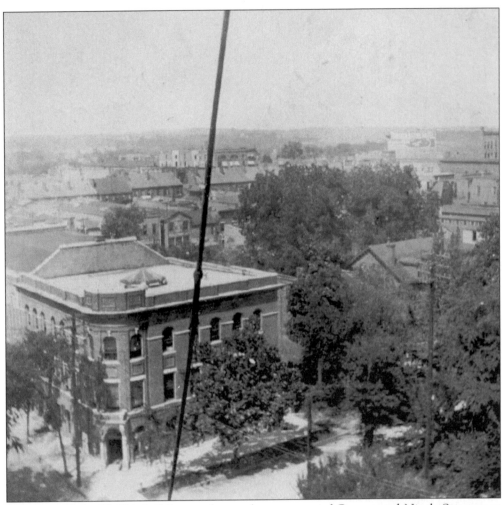

This view of the YMCA building at the northeast corner of Greene and Ninth Streets was taken from the top of the post office tower. The municipal parking deck is in this location today. (Courtesy of Anne Lane, A-184.)

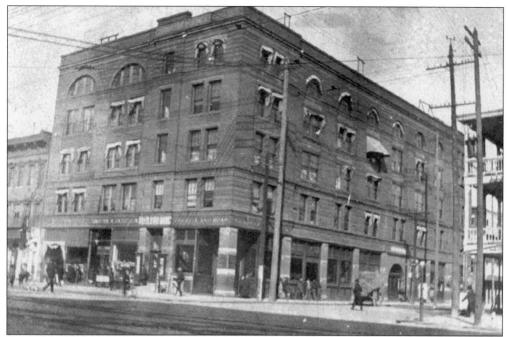

The Dyer Building, at 805 Broad Street on the northwest corner of Eighth, was built c. 1898 by Colonel Daniel B. Dyer, who also brought the electric trolleys to Augusta and developed the Monte Sano section of Summerville. Infamous in Augusta history, it was the site where the great fire of March 22, 1916, began when an electric iron was left on in a dry goods shop in the basement. The central elevator shaft acted as a flue, and flames spread rapidly through the building, only to be blown across the street to the east by high winds. Before the conflagration was over, 32 blocks had been destroyed. (Courtesy of Anne Lane, A-165.)

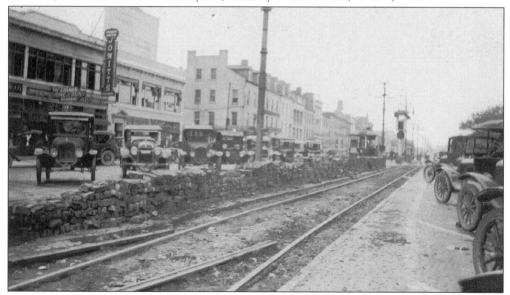

The W.F. Bowe Company paved much of Augusta, including the 700 block of Broad Street, shown here in June 1924. Notice the trolley tracks in the center of the street, and the bricks piled on the side, ready for placement. (Courtesy of Virginia Bowe Strickland, A-210.)

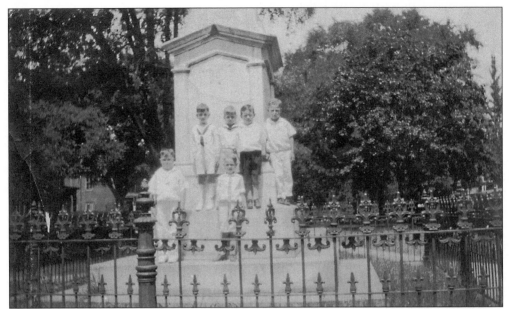

The Saint James Sunday School Monument in the 400 block of Greene Street was the perfect place for a group of young boys to have their picture taken in 1928. From left to right, on the lower level are Irvin Swan and Orville Verdery, and on the upper level are J.C. Anderson, Lewis A. Newman, later to be mayor of Augusta, and two unidentified. (Courtesy of Lewis A. Newman, A-238.)

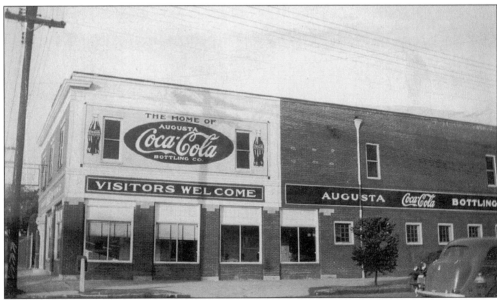

Coca-Cola's Augusta plant was built c. 1918 on the northeast corner of Reynolds and Fifth Streets, next to the Fifth Street Bridge. This 1935 photo shows the large plate-glass windows where the bottling could be viewed from the street, and the sign encourages visitors to come in. (Courtesy of Martha McJunkin, B-230.)

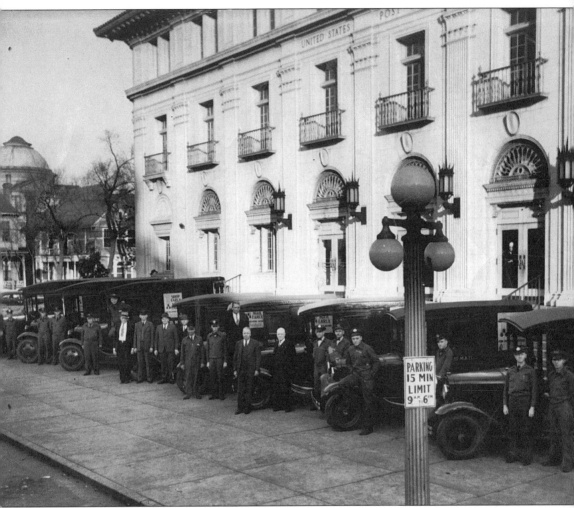

In 1916 the Augusta post office moved from Greene and Ninth Streets to 100 East Ford Street, facing Barrett Plaza and flanking the Union Passenger Station. The local U.S. Post Office motor fleet is shown lined up on the sidewalk in front of the building in this 1936 photo. The mail carriers, from left to right, are Joe Grammer, "Brins" Pharr, Charles H. Clark, Clause W. Hughes, O.B. Scott, Earl Collins, J.J. Edwards, W.C. Beckwith, C.T. Kahrs, E.H. Bergen, Perry Wood, E.V. McClelland, W.H. Vance, Jas. A. Robey, B.E. Lester, Fred Cheeks, Bell Kahrs, Grady Collins, "Moot" Dorn, E.A. Brock, and H.E. Sellers. (Courtesy of Louis F. Servant, A-61.)

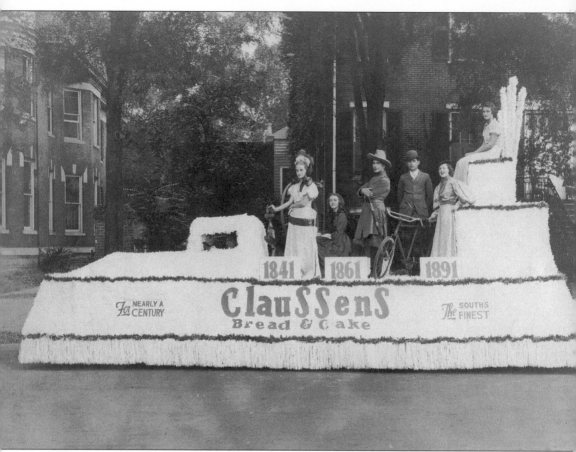

Downtown parades are a longtime Augusta tradition, but they have not always been held on Broad Street. In this c. 1940 photo, the Claussen Bakery float is seen in front of the old Twiggs House at the southeast corner of Greene and Seventh Streets. (Courtesy of John H. Lotz, A-89.)

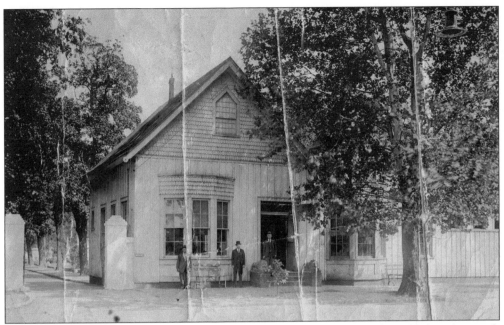

Magnolia Cemetery was established as the city cemetery in 1817 to replace the burial grounds at Saint Paul's Church. This frame office, photographed in 1940, was replaced in the same year by Louise del 'Aigle Reese, whose ancestor, Nicholas DeLaigle, owned the land where the cemetery was located. This building was at the eastern end of Calhoun Street, which was aligned with Walton Way in 1968. (Courtesy of Harriett Whaley, A-371.)

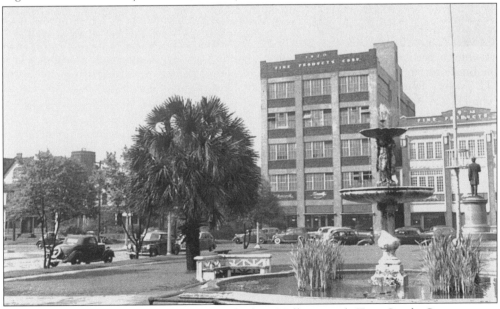

Fine Products Candy Company was formed when Hollingsworth-Tutt Candy Company was merged with Nunnally's in 1932. It was located at 829 Telfair Street facing Barrett Plaza. The tall building on the left was constructed in 1913, and the one on the right was built in 1920. Fine Products Candy Company made maple nut fudge, chocolate-covered cherries, peanut brittle, and hand-dipped chocolate. (Courtesy of Adis Olson, B-78.)

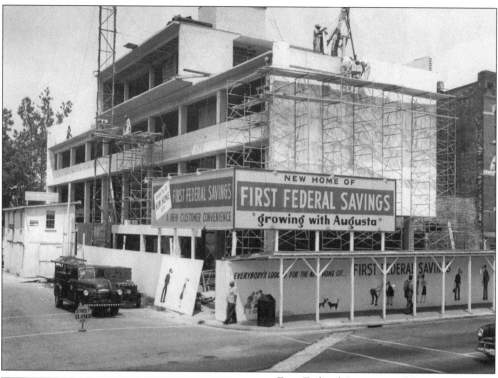

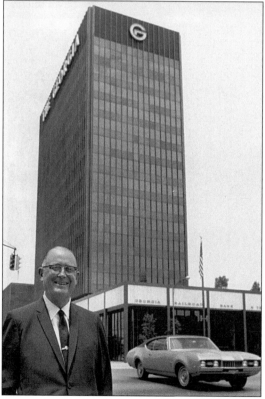

First Federal Savings and Loan constructed a modern building at the northeast corner of Broad and Tenth Streets in 1959. It subsequently became Bankers First, which was bought out by SouthTrust Bank in 1996. Bank mergers had become a common occurrence in the late 20th century, and by the end of the centennial year, none of the banks in Augusta that had existed in the beginning of the century were still in operation under their original names or charters. (Courtesy of Doris A. Jones, B-74.)

In 1967 the venerable Georgia Railroad Bank constructed a new, 17-story black glass and steel office tower, which was the first "skyscraper" built in Augusta since the Lamar Building was completed in 1915. Sherman Drawdy, president at the time, stands in the foreground of the new building at the northeast corner of Broad and Seventh Streets. Georgia Railroad Bank was acquired by First Union in 1986. (Courtesy of Charlotte D. Barrett, A-256.)

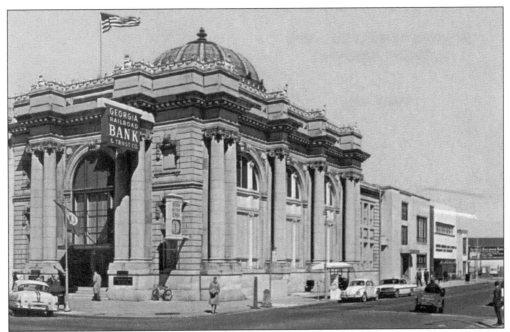

The old Georgia Railroad Bank was across the street from the new one, at the northwest corner of Broad and Seventh Streets. When the old building was remodeled in the expansion of the Citizens and Southern National Bank in 1970, the columns were salvaged, and later used in the design of the new Augusta Museum of History in 1995. (Courtesy of Russell A. Blanchard, A-151.)

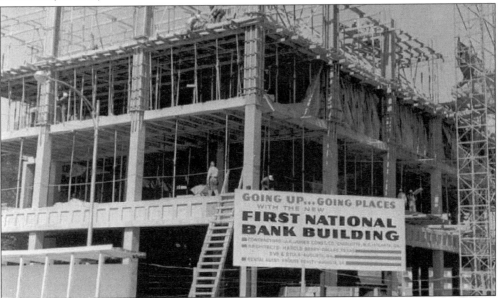

In the race for banking dominance in Augusta, yet another prominent building went up in 1968 with the erection of the First National Bank at 801 Broad Street. Constructed on the site of the Masonic Building, this was also the location where the fire of 1916 started in the Dyer Building. First National was renamed Trust Company Bank in 1984, and subsequently SunTrust Bank in 1995. (Courtesy of Milledge Murray, A-38c.)

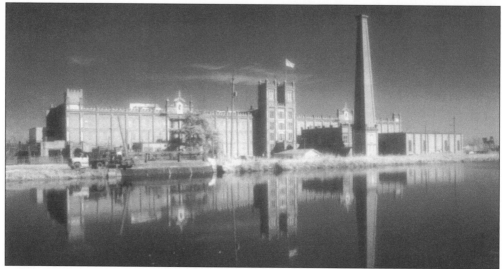

Another survivor of the 19th century still viable throughout the 20th is the Sibley Mill. Located on the Augusta Canal, this entire industrial corridor has been named a National Historic Landmark and was designated by Congress as a National Heritage Area in 1996. Augustans rediscovered the recreational and natural attractions of the canal in the 1980s and 1990s when a master plan was developed with much public input to plot its future. The Confederate Powder Works Chimney is in the foreground. (Courtesy of Katie Jiminez, B-143.)

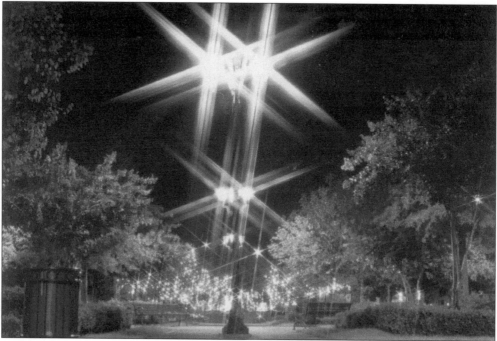

Broad Street lost its dominance as the commercial center of the CSRA after two malls opened in the suburbs in 1978. By the end of the century, it was coming back as a center of entrepreneurial shops, artists' studios, restaurants, and entertainment venues. Holiday lights in the 1990s turned Broad Street into a winter wonderland, as shown in this December 1999 photo. (Courtesy of Carrie Faulkner, A-187.)

Three

ENTERTAINMENT AND LEISURE

Augustans have always been a gregarious people, congregating together for a variety of reasons. When tragedy struck, whether flood or fire, Augustans banded to help one another. For most of their history, they did not rely upon or expect outside help. The civic clubs have contributed to the economic improvement of the community, cultural organizations have sponsored the fine and performing arts, and religious groups have helped the needy. Included in this section are random selections of organizations, families, and groups who illustrate the variety and richness of life in Augusta in the 20th century.

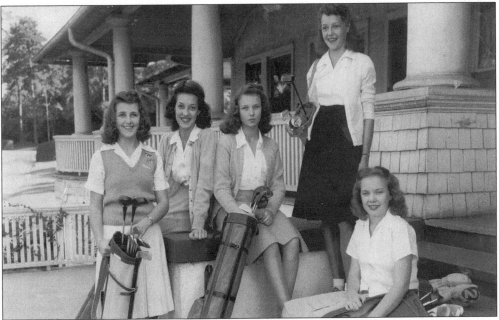

The "Toppy" Club was a golf club named in memory of Anne Creamer, a 15-year-old Augustan (called Toppy by her father, Harry R. Creamer) who died in an automobile accident in September 1941. Pictured on the steps at Augusta Country Club in 1941, from left to right, are Denese Smith (Lee), Frances Elliott, Mary Cleckley (Creson), Ann Claussen, and seated, Carolyn Mobley. (Courtesy of Denese Lee, A-325.)

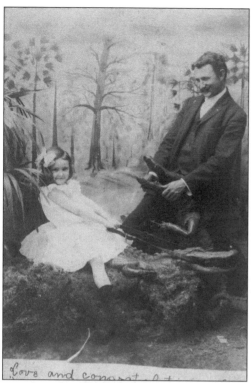

Dr. Robert James Videtto is seen with his granddaughter Roberta Howard Videtto in a 1908 picture. Dr. Videtto rode a horse-and-buggy to visit his patients in the rural areas of Richmond and Burke Counties, and in later years made house calls in his model A Ford. He is credited with patenting one of the first aspirin medications, called "Head Eye Ease," in Augusta. (Courtesy of Roberta Robinson Reinert, A-51.)

The dedication of the Meadow Garden Monument is pictured in 1920. George Walton, the youngest signer of the Declaration of Independence and twice governor of Georgia, lived in the home from 1792 until his death in 1804. The home is listed on the National Register of Historic Places and has been maintained by the Georgia Chapter of the DAR as a museum since 1900. Walton and Lyman Hall, another Georgia signer, are buried on Greene Street at the Signers Monument. (Courtesy of Virginia de Treville, A-138.)

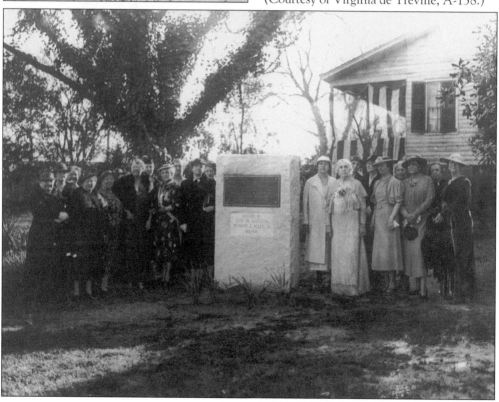

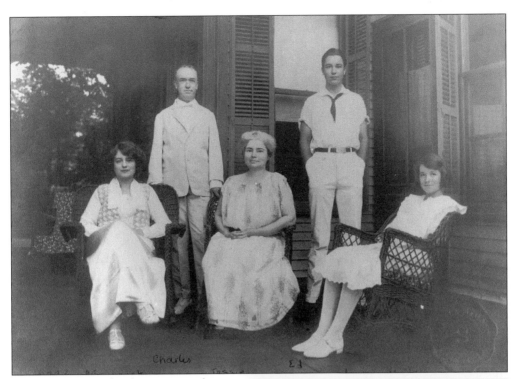

Charles E J

The Montgomery family are pictured at their home at 918 Johns Road. Seated from left to right are Margaret Montgomery (McGovern), Jessie Scott Montgomery, and Anna Montgomery (Merrill). Dr. Charles J. Montgomery is standing left and Edward A. Montgomery, his son, is right. The side porch of the home led into Dr. Montgomery's office and examination rooms. Doctors of that period often had offices in their homes. (Courtesy of Eleanor Hoernle, B-139.)

Lee and Clem Castleberry are seen at an outing at Langley Lake in 1926. C.S. "Clem" Castleberry was the owner of Augusta-based Castleberry's Product Company, founded in 1927. Packers of canned meats and sauces, Castleberry's is located at 1621 Fifteenth Street. Mr. Castleberry's father, C.S. Castleberry, was well known for his barbecue long before the business was opened. The company is still in operation today at the same location. (Courtesy of Denese Smith Lee, A-328.)

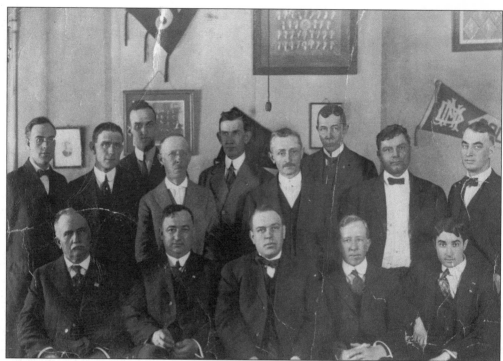

Members of the Augusta Builders Exchange are seen in a photo taken at Richmond Academy on Telfair Street in 1922. (Courtesy of Donna Whaley, A-25.)

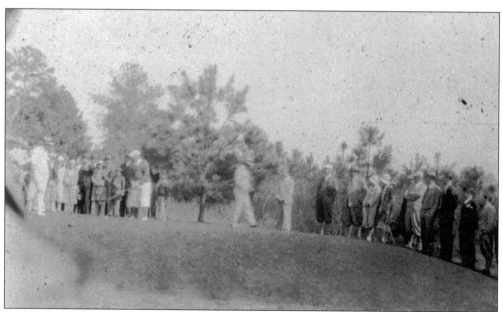

Golfing legend Bobby Jones is pictured on the links at Forrest Hills Golf Course. Jones won the Southeastern Open of 1930 on the Forrest Hills Ricker course, and went on that year to win the British Amateur, the British Open, the U.S. Open, and the U.S. Amateur—the Grand Slam of golf and a feat yet to be repeated. Jones played as an amateur all of his life. (Courtesy of Cobbs Nixon, B-33.)

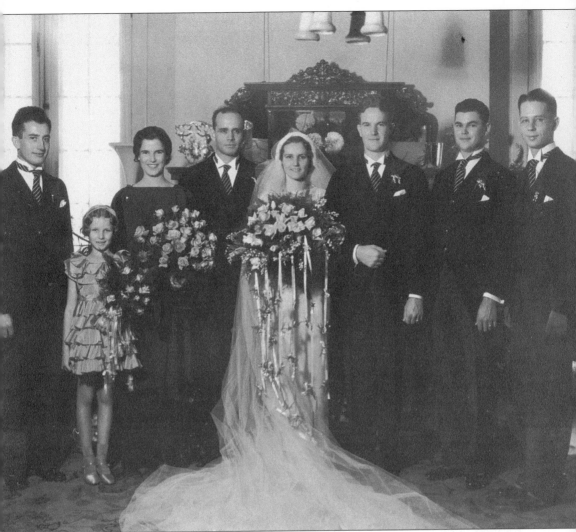

Pictured at the wedding of Connor Cleckley and Aquilla James Dyess on November 7, 1934, are, from left to right, Claud Caldwell, Mary Cleckley (Creson), Mrs. Cleckley, Dr. Hervey Cleckley, Connor Cleckley, Aquilla James Dyess, Preston Motes, and John Lawrence Dantzler. Jimmie Dyess was awarded the Carnegie Medal in 1929 for saving the lives of Mrs. Roscoe Holley of Augusta and Miss Barbara Muller of Charleston while they were swimming at Sullivan's Island off the Charleston coast on July 13, 1928. The Carnegie Medal was established in 1904 as an award to heroes who risk their lives during peacetime. Lieutenant Colonel Dyess was later awarded the Congressional Medal of Honor in WWII for heroic action. He is the only person in history to have been awarded both medals. (Courtesy of Claud Caldwell, A-290.)

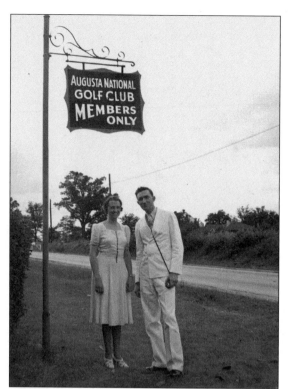

Helen L. Wolfe and her cousin Aubin Mura are pictured outside the Augusta National in the late 1930s. The Augusta National was established in 1934 on the property of Fruitland Nurseries, which was owned by Dennis Redmond. Redmond built the clubhouse as his family home c. 1853. Louis Berckmans and his son Prosper J.A. Berckmans bought the nursery in 1858. (Courtesy of Adis Olson, B-80.)

The widows, wives, and families of Spanish-American War Veterans gather at a local hotel in Augusta, c. 1932. Pictured on the back row left is Maggie Moring, and fifth from the left on the back row is the president of the organization, Margret Othello Moring Frierson. (Courtesy of Annette Dobyne, B-107.)

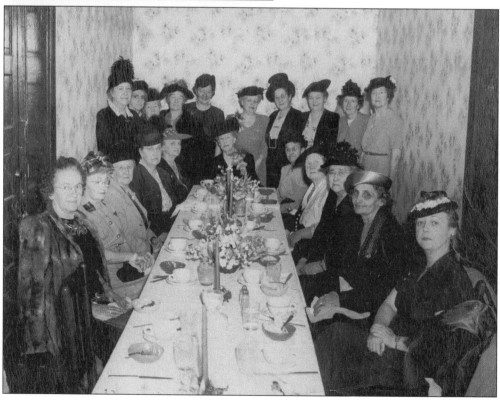

Thelma "Butterfly" McQueen gained fame as "Prissy" in the giant film of 1939: *Gone With the Wind*. Ms. McQueen and her mother, a native Augustan, moved back home with her grandmother when she was five years old. She attended elementary school at Walker Baptist Institute and moved to New York in 1924 at age 13. In 1937 she became involved in an African-American youth theatre group in Harlem. (Courtesy of Justine W. Washington, A-341.)

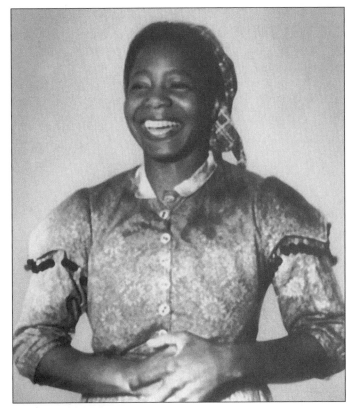

A popular shopping spot on any given day was Broad Street in downtown Augusta. Shown in the summer of 1943 are nine-month-old twins Carolyn Smith (Amerson) and Harold Smith. The family lived in Grovetown but came to Augusta often to shop. Broad Street's wide sidewalks were always busy with the many shoppers who crowded the downtown stores of Augusta. (Courtesy of Harold I. Smith, B-131.)

45

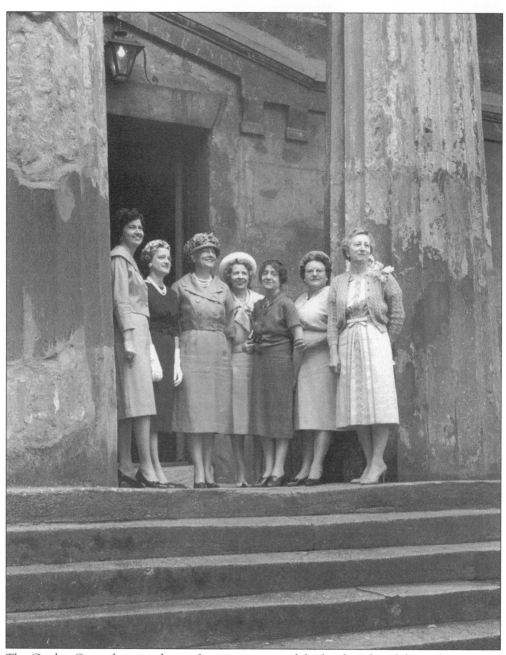

The Garden Council was made up of representatives of the local garden clubs in the area and held meetings at the Old Medical College. Shown are the council presidents on the steps in 1963. Pictured from left to right are Nell Golosky, Mattie McCormack, Mrs. Perkins, Sara Marks, Tracy Cohen, Mrs. Persky, and Fairy Drawdy. (Courtesy of Charlotte D. Barrett, B-260.)

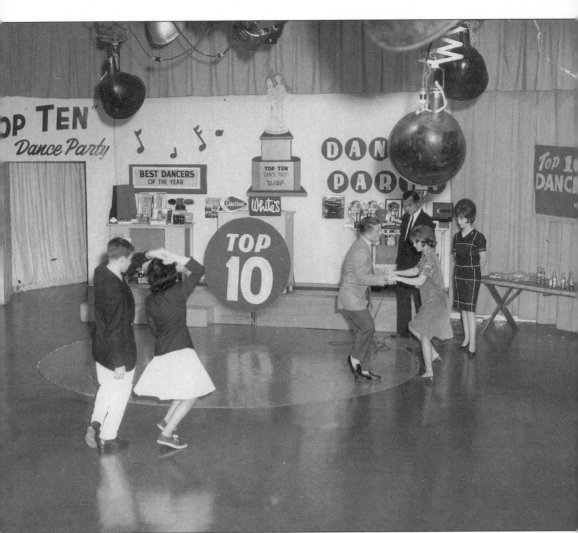

A landmark in Augusta television was WJBF's *Top Ten Dance Party*, hosted here by Carroll Ward and Georgia Cribb (Cunningham) during the 1960s. The program aired immediately before *American Bandstand* on ABC, from the late 1950s until 1973. Hundreds of Augusta teenagers came to the station from outlying schools to dance to the most popular rock-and-roll tunes of the day. Each week a couple won the dance contest and were invited back periodically to compete for "best dancers of the year." The show was featured in a *TV Guide* article in 1965. (Courtesy of Louis Wall, B-383.)

For many years Mrs. Henri Price taught ballroom dance, tap, and ballet to Augusta youths. Each spring hundreds of families would attend recitals at the Bell Auditorium Music Hall to see her students. The above photo was taken c. 1946 and shows classes in her "Social" ballroom dance program. The program continues to this day under the direction of Mrs. Dorothy Wright McLeod. (Courtesy of Annette Dobyne, B-109.)

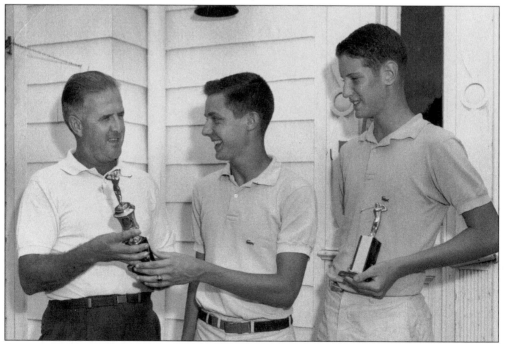

Augusta Country Club golf professional Frank Carney is seen in 1959 with the club junior champions, Haley Roberts (first place) and Nick Greene (runner-up). (Courtesy of Nick Greene, B-218.)

Popular performers in Augusta, Florence Carter and the Golden Campers perform at the Golden Camp Inn on Golden Camp Road in 1955. The inn was a popular nightspot for Augustans until it burned in the late 1950s. Pictured performing are Florence "Flo" Carter, vocalist (foreground); Don Carter, drummer ; Al Sullivan, guitar; Tom Edenfield, bass; and Chuck Connors, trumpet. (Courtesy of Florence Carter, B-334.)

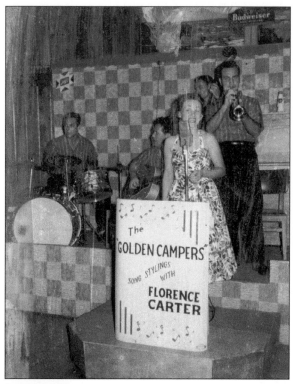

Two young men are pictured at Sunset Homes in the early 1960s. Sunset Homes and Olmstead Homes were Augusta's first public housing projects and were funded by the New Deal Public Works Administration. (Courtesy of George Hamilton, A-3.)

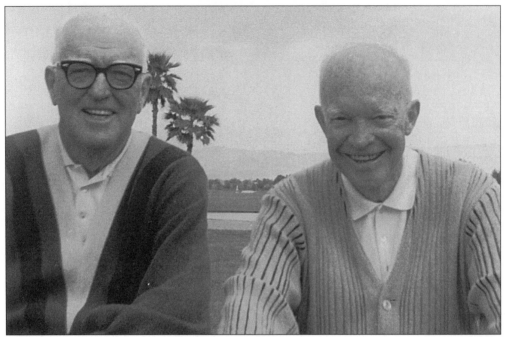

John L. Murray Sr. is seen with President Dwight David Eisenhower on a golf outing *c.* 1965. Murray came to Augusta in 1934 and introduced margarine to the area through Murray Brothers Distributing Co., Inc. In 1941, he acquired a cookie oven through payback of a debt and Murray Biscuit Company was born. The company was sold in 1965 to Beatrice Foods. (Courtesy of Larry Murray, B-214.)

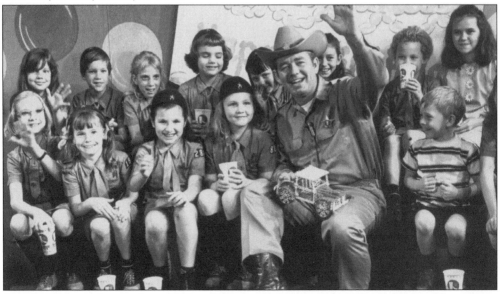

Another Augusta favorite from 1961 to 1981 was the *Trooper Terry Show* with host Terry Sams, who entertained Augusta children at the WJBF studio. The telecast was live each Saturday morning and hosted over 100,000 Augusta children for birthdays, school outings, and organized group events. This photo shows a Brownie scout troop in the late 1960s. (Courtesy of Louis Wall, B-376.)

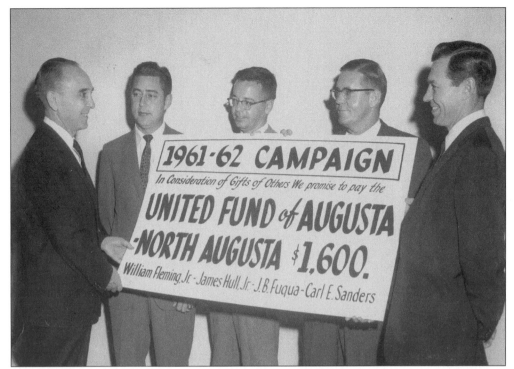

The chairman of the United Fund of Augusta, Russell Blanchard (left) is shown with (from left to right) William Fleming Jr., James Hull Jr., J.B. Fuqua, and Carl E. Sanders as they present a check for $1,600 to the 1961–1962 campaign drive. (Courtesy of Russell Blanchard, A-154.)

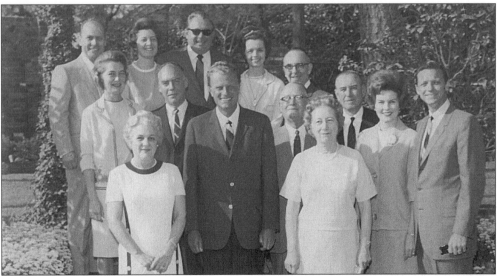

The Reverend Billy Graham is pictured with friends in Augusta at the home of Mr. and Mrs. Sherman Drawdy at 3008 Park Avenue. Seen from left to right are (front row) Catherine Blanchard, Billy Graham, Fairy Drawdy, and Reverend and Mrs. Jack Robinson; (middle row) Mr. and Mrs George Sancken, Sherman Drawdy, and unidentified; (back row) Doug Barnard, Charlotte D. Barrett, unidentified, Nopi Barnard, and Russell Blanchard. (Courtesy of Charlotte D. Barrett, B-259.)

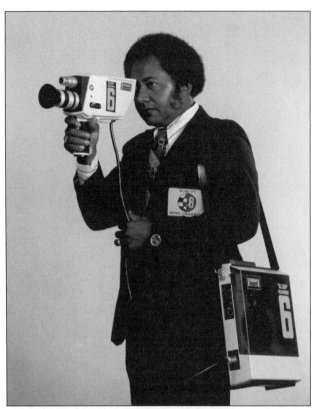

Frank Thomas was Augusta's first African-American television reporter. WJBF Channel 6 hired Thomas in the early 1970s. (Courtesy of Louis Wall, B-377.)

WJBF, shown at the start of the 25th anniversary Turkey Trot Race in 1976, opened in 1951 as an NBC affiliate station. The station advertised that it was owned and operated totally by Augustans. The general manager and president was Augusta businessman J.B. Fuqua. It would later become the first station in Georgia and South Carolina to air programs in color. (Courtesy of Louis Wall, A-377.)

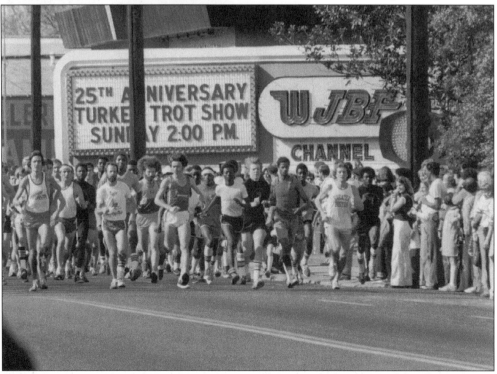

Lieutenant Commander Susan Still, a native Augustan, stands in front of the Cotton Exchange Building at Riverwalk and Eighth Streets on "Susan Still Day" in Augusta, September 27, 1997. Ms. Still piloted Columbia shuttles for NASA space flights STS-83 on April 3, 1997, and STS-94 on July 18, 1997. A parade was held in downtown Augusta to honor the hometown girl who attended Forest Hills Elementary and Langford Middle School. (Courtesy of Lillian Wan, B-97.)

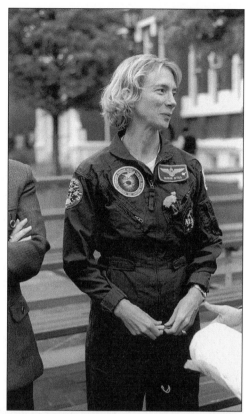

In November 1996, President Bill Clinton is seen at the Augusta State University Athletic Complex with ASU Athletic Director Clint Bryant and his wife, Trish (shaking hands with the President), and daughters Lauren and Kristen (left and right, respectively). The President spoke to students, faculty, and the community about education issues in the state of Georgia. (Courtesy of Kristen Bryant, B-364.)

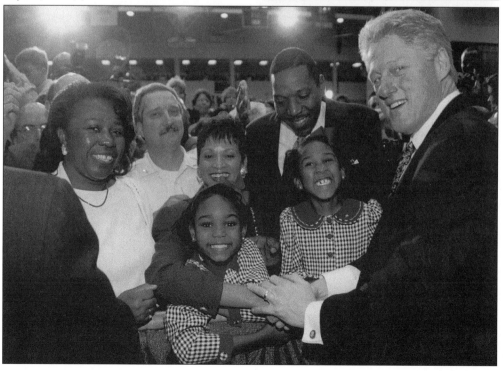

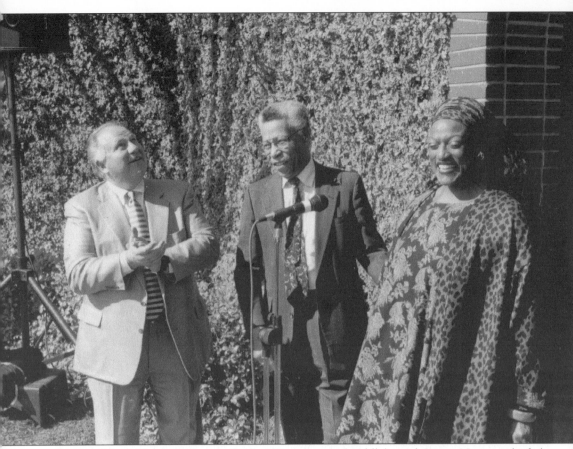

Augusta Mayor Larry Sconyers (left), Ellis Johnson (middle), and Jessye Norman (right), considered the reigning diva of classical music in the world today, are shown at Riverwalk in front of a plaque naming the amphitheater in her honor in 1996. Ms. Norman, born in Augusta on September 15, 1945, one of five children of Silas and Janie King Norman, was educated in Augusta schools and participated in the choir at Mount Calvary Baptist Church. (Courtesy of Ann Johnson, A-267.)

Four
SCHOOLS AND
CHURCHES

The pictures in this chapter depict some of the best memories of Augustans over the years—church and school activities, class photos with pictures of educators and friends, places gone but not forgotten by longtime Augustans. Because of space limitations, initials have been used for first names in some of the class photos.

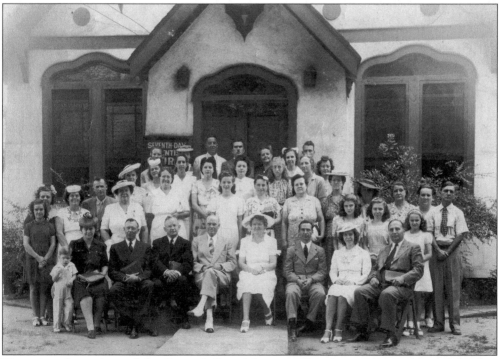

The original members of the Seventh Day Adventist Church are seen in front of the first church building at 1824 Walton Way. When this building became too small in 1951, the Marioni Rest Home on Katherine Street was converted into a church and school under the leadership of Elder H.W. Walker. A third church building and school at 2514 Richmond Hill Road were consecrated on February 11, 1967. (Courtesy of Annette Dobyne, B-98.)

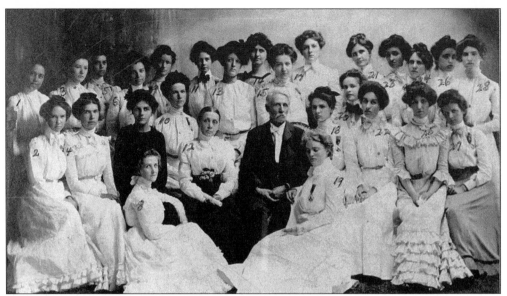

The Tubman High School Graduating Class of 1901 is pictured in the original building on Reynolds Street. In 1877 Neely's Institute became Tubman School; it was named after Emily Tubman, an Augustan who donated the building. Tubman School today is located at 1740 Walton Way and houses a middle school. (Courtesy of Doris A. Jones, B-72.)

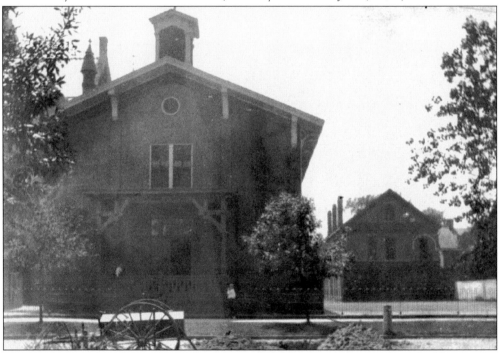

Pictured here is the Philosophy Hall of the Sacred Heart College Academy building. Jesuit priests ran the school in the 1900s, and it closed during WWI. The building pictured was originally built as Sacred Heart Church in 1875. The school was the first college in Augusta for white students, Paine College having been established for African-American students in 1882. The first baccalaureate degrees were awarded in 1905. (Courtesy of Anne Lane, A-194.)

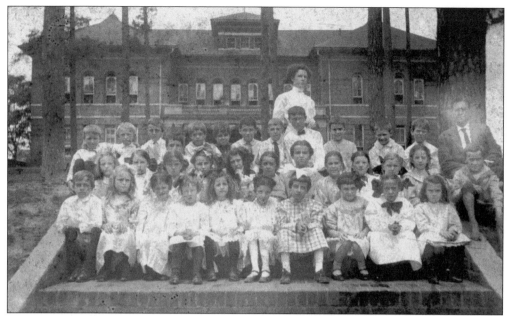

Woodlawn School's first grade class is pictured in the spring of 1907. The old Woodlawn Elementary School on Fifteenth Street is seen in the background. Alma Floy Videtto is the teacher standing in the rear. Students include Roberta Howard Videtto (eighth from left), Lillian Mallard (fourth from left), and Georgia Kay (third from left). (Courtesy of Roberta Robinson Reinert, A-53.)

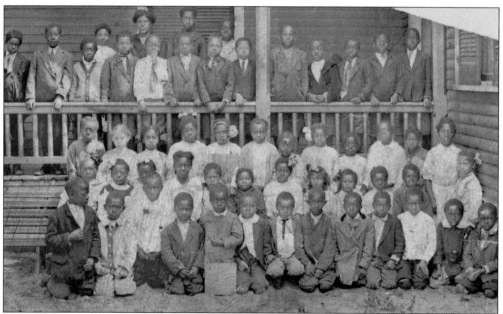

The original Weed Elementary School was a wooden building bordered by Mt. Auburn Street, Montgomery Street, and Weed Street. This photo, taken in 1913, is of students attending the school. A new building was constructed in the 1930s and is used today by the Richmond County Board of Education as the Sand Hills Psychoeducational Center, servicing Richmond County students with special education needs. (Courtesy of Josephine A. Richardson, A-148.)

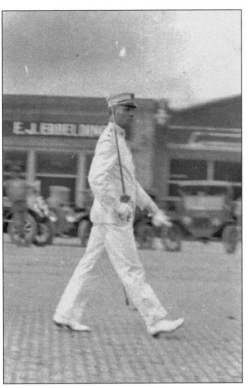

Major George P. Butler, commandant at the Academy of Richmond County, is seen in a parade on Broad Street, April 26, 1917. In the background is the E.J. Erbelding office building. Butler was later named principal at the Academy and was the first president of the Junior College of Augusta, established in 1925. George P. Butler High School was named for him in 1959. (Courtesy of Mrs. Virginia Bowe Strickland, A-130.)

Students, teachers, priests, and Franciscan sisters are pictured on the first day of class at Immaculate Conception School on the southeast corner of Eleventh Street and Laney-Walker Boulevard, c. 1913. (Courtesy of Sister Margaret Mary Mohr, A-330.)

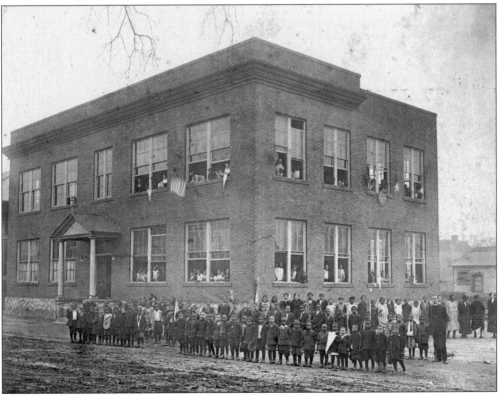

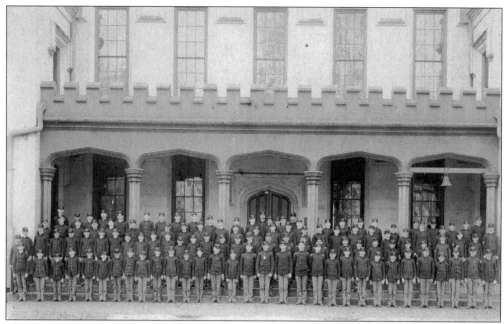

The Academy of Richmond County cadets are pictured in front of the school building on Telfair Street, c. 1920. Harry L. Newman and Roscoe L. Newman, brothers of Augusta Mayor Lewis A. "Pop" Newman, are included in the photo. The building later became the Augusta Public Library, and later the Augusta Richmond County Museum. (Courtesy of Lewis A. Newman, A-236.)

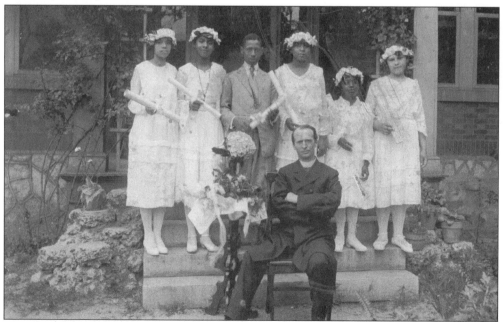

The first graduating class of Immaculate Conception High School is pictured June 1, 1923. Seated is the Reverend A.J. Laube; girls identified are, from left to right, Julia Gatlin, Lucille Green, Berniece Mays, and Miriam Sturgis. The gentleman in the center is Alphonsus J.D. Culbreath. (Courtesy of Sister Margaret Mary Mohr, A-332.)

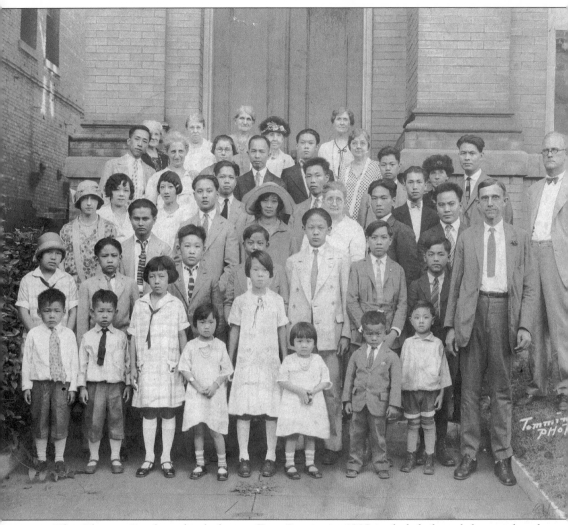

The Chinese Sunday school class at First Baptist in 1927 included, from left to right, the following: (first row) G. Joe, A. Joe, E. Joe, M. Woo, B. Woo, M. Woo, H. Joe, and H. Woo; (second row) F. Joe, T. Eng, W. Joe, R. Joe, A. Eng, H. Woo, C. Woo, and C.D. Johnston; (third row) C. Hogan, A. Eng, D. Joe, H. Woo, unidentified, M. Joe, Mrs. Dicks, K. Lee, J.P. Wong, W.L. Tong (Leong), and ? Bridges; (fourth row) K.F. Wong, unidentified, Mrs. S. Woo, S. Woo, W. Hang, unidentified, unidentified, ? Bridges, unidentified, M. Brown, and L. Woo; (fifth row) unidentified, W.B. Verdery, Mrs. Lightfoot, Mrs. Spragul, H. Eng, and L. Johnson. (Courtesy of Joseph M. Lee III, B-169.)

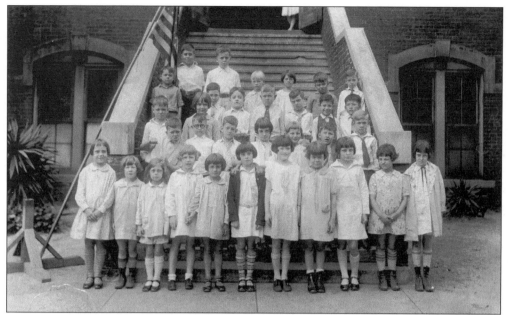

This 1929 class portrait is of the third grade at Central Grammar School, located at Seventh and Telfair Streets across from the boyhood home of Woodrow Wilson. The original building was constructed in 1888. (Courtesy of James B. Duncan Jr., A-201.)

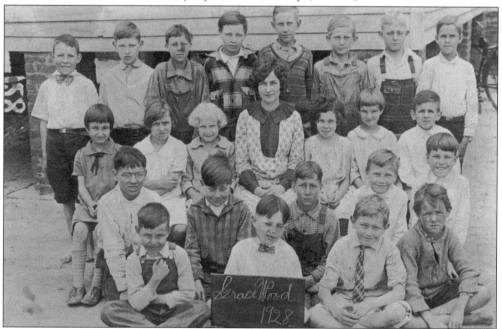

This 1928 class portrait is of the fourth and fifth grades at Gracewood Elementary School. Pictured from left to right are (first row) E. Byrd, H. Dinkins, unidentified, and L. Hoover; (second row) H. Smith, ? Duncan, unidentified, R. Oellerick, and C. McKie; (third row) M. Jeffcoat, T. Smith, M.L. Crenshaw, Miss Ruby Logue, L. Toole, D. Seago, and G. Futrell; (fourth row) A.Toole, C. Baldoski, ? Kitchens, three unidentified students, J. Skinner, and ? Helmly. (Courtesy of Cliff McKie, A-118.)

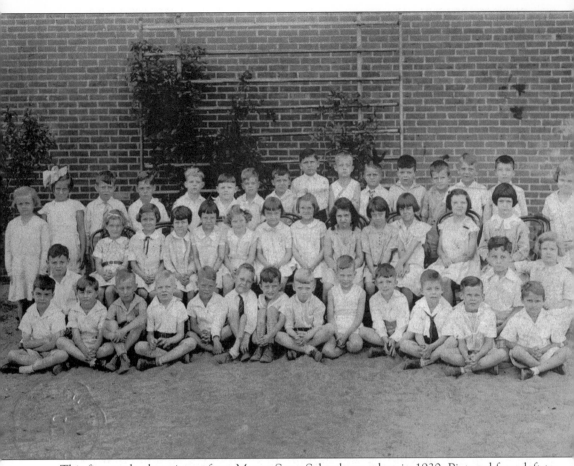

This first grade class picture from Monte Sano School was taken in 1930. Pictured from left to right are (front row) C. Williamson, B. Thomas, C. Lewis, R. Wingard, Billy ?, J. Jones, Jack ?, A. Brinkley, P. Houck, K. Houck, P. Thompson, W. Hamilton, Clark ?, unidentified, and unidentified; (middle row) B. Balk, A. Kelly, D. Smith, B. Hallman, Ruth S., J. Culpepper, Virginia ?, M.H. Robinson, J. Silver, Margaret ?, Effie ?, M.N. Hardy, Nellie ?, L. Markwalter, and M. Toole; (back row) Nita ?, Betty Jane ?, C. Sanders, Eugene ?, B. Norvell, M. Brooks, A. Murphy, C. Cordle, unidentified, G. Rich, C. Royal, G. Kelly, B. Chandler, W. Herndon, W. Prather, and B.J. Allen. (Courtesy of Charles C. Royal, A-45.)

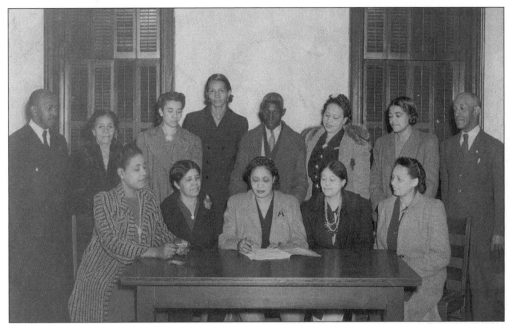

The board of trustees of the Haines Normal Industrial Institute met in the library c. 1930. The board was made up of community volunteers, faculty, and parents. Pictured at the table, from left to right, are Ms. Willie Hibbler, Mrs. Jerrylyn Walker Dent, and Mrs. Emma Newsome. (Courtesy of Elizabeth B. Brown, B-212.)

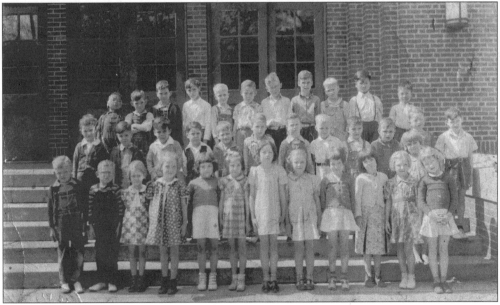

This first grade class picture was taken at John S. Davidson Elementary School on Telfair Street in 1939. Included in the photo are Daisy Kight Gallegos, first row, second from right; Jimmy Mallett, second row, second from left; Walter Lum, third row, first from left; and Winthrup Chambers, third row, second from left. The building housed the John S. Davidson Fine Arts Magnet School from August 1981 until January 1996, when the school moved to its new building at 615 Twelfth Street. (Courtesy of Daisy Kight Gallegos, A-63.)

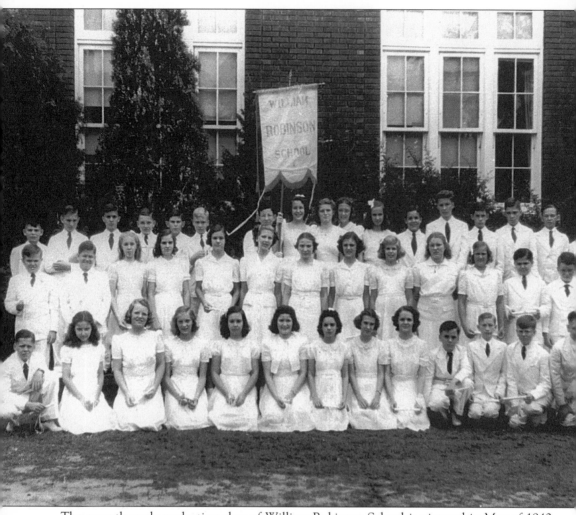

The seventh grade graduating class of William Robinson School is pictured in May of 1940. Seen from left to right are (bottom row) T. Hodges, D. Morris, M.B. Barrett, U. Drawdy, S. Bussey, S.B. Slusky, L. Goldberg, V. Martin, S.H. Hardy, H.M. Kirby, G.C. Roesel, G.C. Maxwell Jr., and J. Mills; (middle row) D.D. Boardman, B. Grear, S. Middleton, D.L. Davenport, M. Graves, B. Nance, E. Willingham, B. Boardman, A. Maxwell, J. Hildebrandt, A. Morehouse, J.C. Shapiro, and J. Phinizy; (top row) A. Goodwin, O.Moore, A.M. Martin, F.M. Calhoun, W.M. Lester Jr., H.C. McGowan Jr., B.P. Mays, M. Boatwright, A. Burdeshaw, A. Parkeson, R. Gowan, A.H. Merry II, J. Jakes, G.R. Bailie Jr., J.S. Smith, H. Willingham, and J.C. Hooper. (Courtesy of Julia Bohlmann, B-114.)

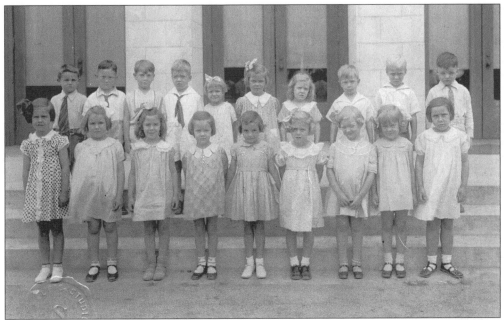

The Mount Saint Joseph Kindergarten Class of 1932 included, from left to right, (front row) Martha Ann Groves, Julia C. Hildebrandt, Annette Bassing, Mary Ann Brotherton, Jane Markwalter, Marian Mulherin, Mary Ann Bresnahan, Carmel Park, and Betty Thompson; (back row) unidentified, Inman Phillips, Jack Lenz, Edward Cashin, Bebe Wheeler, unidentified, Ann Heslen, Billy Gray, Henri McGowan, and Billy Lyons. (Courtesy of Julia Bohlman, B-113.)

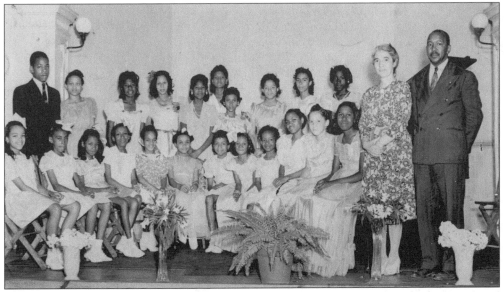

The school chorus at Haines Normal and Industrial Institute is pictured in the 1940s. Choral Director Rosa Tutt and Principal Reverend A.C. Griggs are seen with the students. Lucy Laney opened this school on January 6, 1886, in the basement of a Presbyterian church and later moved the school to a building at 505 Calhoun Street. (Courtesy of Elizabeth B. Brown, B-209.)

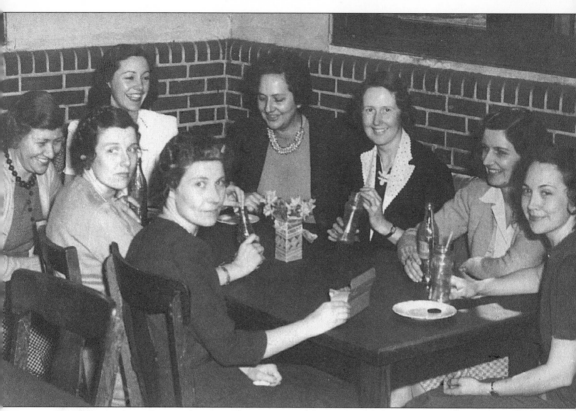

Teachers are seen having lunch at Tubman High School for girls on Walton Way. Pictured are (clockwise from bottom left) Marie Hulbert, Betty Jones Haskell, Eleanor Boatwright, Valusia Anchors, Ann Braddy, Grace Strauss, Ruth McAuliffe, and unidentified. Miss Boatwright, Miss Braddy, Miss Strauss, and Miss McAuliffe were affectionately known as "the big four" to the Tubman students. The school was named for Emily Tubman and originated in 1874 as a female high school housed in the original First Christian Church at 711 and 713 Reynolds Street. Faculty consisted of one woman and one man, and the first class of six girls graduated in 1877. (Courtesy of Eleanora Hoernle, A-85.)

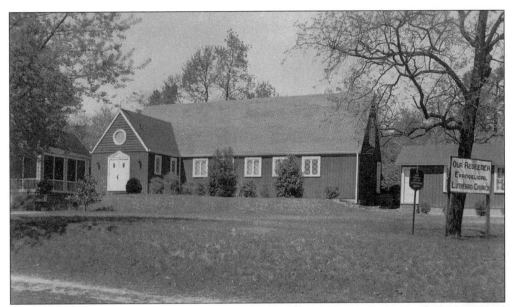

Our Redeemer Lutheran Church is pictured at the corner of Central Avenue and Johns Road in 1949. The congregation built a new sanctuary at 402 Aumond Road in 1960. The original building houses another church today, Christ Church Unity. (Courtesy of Julia Bohlmann, B-118.)

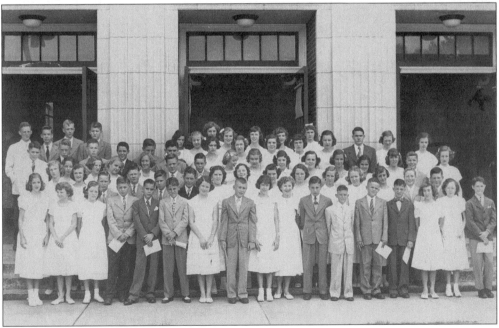

The seventh grade graduating class of Monte Sano Elementary School is pictured in 1950. Some of the students identified on the first row, from left to right, are Nancy Ford, Eleanor Perkins, Gail Leverett, George Marschalk, Ronald Coursey, Lee Parks, Susie Baggott, George Bolt, Martha Ann Davis, Josephine Blackstone, Clark Willingham, John Drew, Alfred Yarbrough, Hilton Canady, Mary Lee, Betty Munk, and Davie Jones. Other students have not been identified. (Courtesy of Paula Hyams Jackson, B-183.)

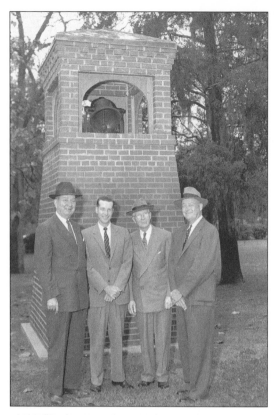

Pictured in front of the bell tower at Augusta Junior College in 1957 are, from left to right, Oliver Mixon; Gerald Robins, president of Augusta College 1957–1970; Eric Hardy, president of the Junior College of Augusta 1937–1954; and Sherman Drawdy, president of the Georgia Railroad Bank and Trust Company, 1947–1969. (Courtesy of Charlotte D. Barrett, B-256.)

The seventh grade graduating class of William Robinson Elementary School is pictured in May 1957 at the Richmond Hotel on Broad Street. Seen from left to right are (front row) C. Shaffer, A. Dwinga, N. Smith, F. McKnight, H. Jones, C. Fox, G. Gentry, J. Harrison, D. Mansfield, L. Thompson, M. Philpot, M. Martin, R. Asserson, and S. Ashmore; (back row) Betty Asserson (teacher), S. Steinberg, S. Vallotton, J. Bowles, J. Pierce, D. Davison, C. Kaynard, D. Dearing, M.A. Avery, G. Fuller, J. Zimmerman, D. Fortson, F. Sandifer, and D.L. Hendee. (Courtesy of Sally Ashmore Carter, A-20.)

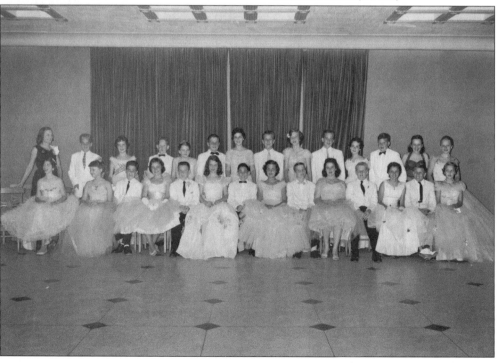

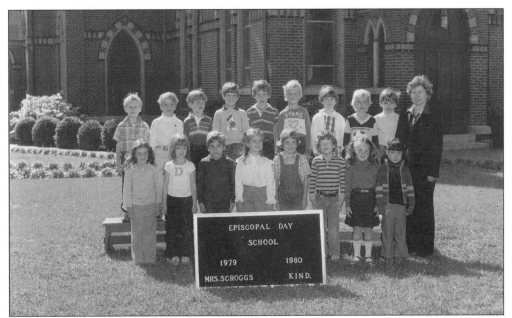

Martha Scroggs (at right) will celebrate her 45th year as a kindergarten teacher at Episcopal Day School on Walton Way in January 2001. Pictured is the 1979–1980 kindergarten class in front of The Church of the Good Shepherd; they are, from left to right, as follows: (front row) D. Easley, D. Drew, R. Swann, C. Gayle, A.B. Murray, J. Overstreet, N. Boardman, and P. Huntrakoon; (back row) P. Nelson, B. Garrett, D. Curley, C. Bagby, S. Slaby, S. Moore, C. Greene, B. Patty, S. Bailey, and Mrs. Scroggs. (Courtesy of Vicki Greene, B-213.)

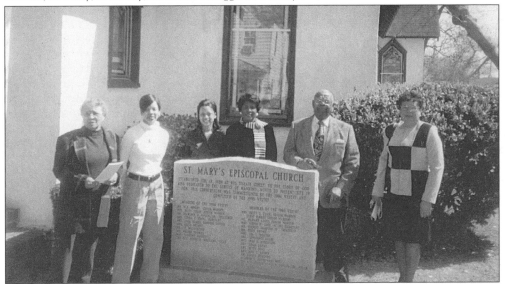

On February 20, 2000, the memorial tablet at St. Mary's Episcopal Church at 1114 Twelfth Street was dedicated. The original building was constructed in 1889 and was located at 903 Telfair Street. Seen here at the second building, erected in 1928, are, from left to right, Mrs. Richard Alsop, Mrs. Alexis Tyler, Miss April Tyler, Mrs. Milton L. Tyler, Dr. Isaiah E. Washington (senior warden), and Mrs. W.B. Bryant (former senior warden), who spearheaded the dedication of the marker. (Courtesy of Betty E. Tyler, A-250.)

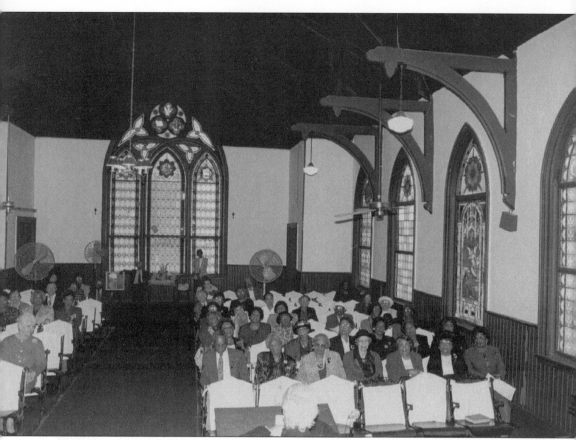

Pictured in a 1996 photo at Union Baptist Church are community volunteers at an annual awards ceremony for citizens who serve the community. The service was sponsored by the Black History Committee, founded by Augustan Philip Waring, a well-known African-American educator, historian, and social worker. The church was built in 1851 as Greene Street Presbyterian and acquired in 1883 by Union Baptist, an offshoot of Springfield Baptist that had been founded in 1879. The chairs pictured are the original folding chairs with white cotton covers, kept immaculate by the Ladies Auxiliary of the Church. Restoration of the historic stained-glass windows has recently begun by Schweitzer Glass Company of Augusta. (Courtesy of Edythe Dimond, B-205.)

Five

SAVANNAH RIVER AND AUGUSTA CANAL

The Savannah River, with Augusta at the head of navigation, is inextricably woven into the community's past, present, and, undoubtedly, its future. For more than 12,000 years, the river has attracted and subsequently supported human life in the region. The river is characterized as a thoroughfare for travel and commerce; a nourishing element of fertile soil; a harnessed source of hydroelectric power; a catalyst for recreational activity; and, particularly in its past, the cause of devastating floods. Its permutations notwithstanding, the Savannah River maintains one constant—the centerpiece of community pride.

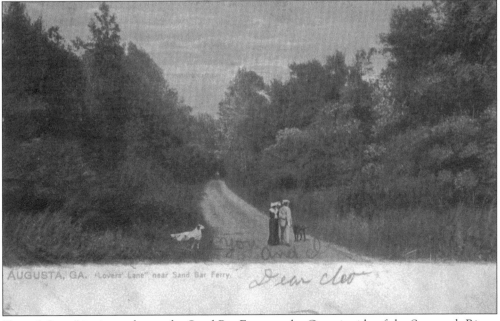

"Lover's Lane" is pictured near the Sand Bar Ferry on the Georgia side of the Savannah River, c. 1907. The ferry operated below Augusta for decades, until it was replaced with a bridge in the 1920s. (Courtesy of Mrs. John T. Newman, A-116.)

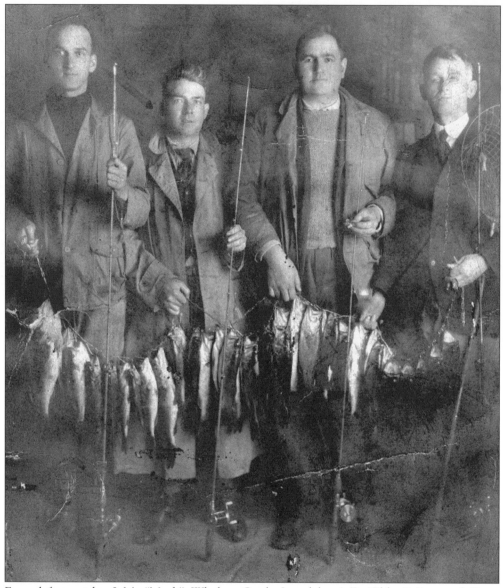

From left to right, L.M. "Mack" Whaley, Grady Lansdale, A.E. "Eldon" Fox, and Percy Burum hold a full stringer of fish caught in the Savannah River, *c*. 1910. (Courtesy of Donna Whaley, A-30.)

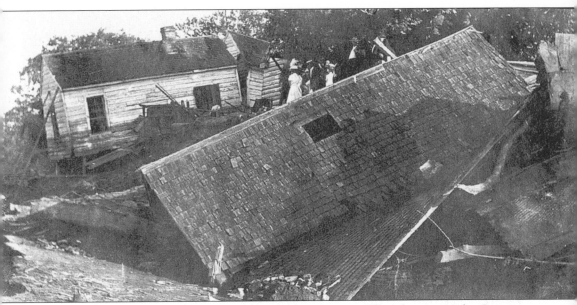

The 1908 flood remains one of the worst on record in Augusta. These houses on the Georgia side of the Savannah River were nearly swallowed by the floodwaters. (Courtesy of Anne Lane, B-262.)

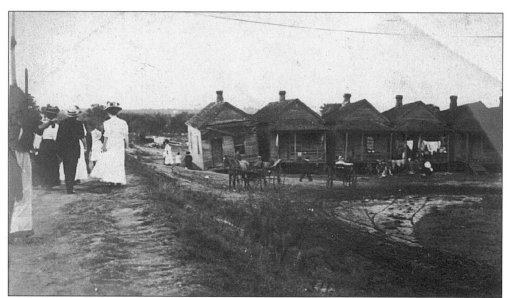

The floodwaters of the Savannah River roared on numerous occasions in the 19th and early 20th centuries. The construction of a levee was suggested after the flood of 1888. The devastating flood of August 1908 inundated many downtown blocks and damaged both the North Augusta (Thirteenth Street) and Hamburg (Fifth Street) bridges. Construction of a 3.5-mile levee began in 1913, and was completed in 1919. Pictured are shotgun houses near the North Augusta bridge that sustained damage from the 1908 flood. (Courtesy of S. Marshall Sanders Jr., B-349.)

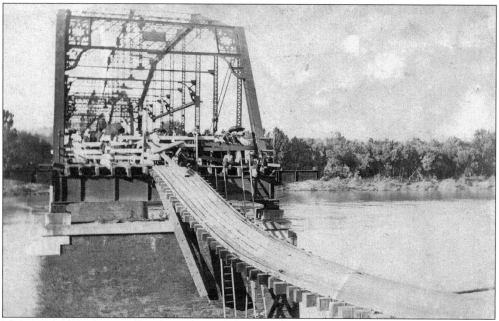

This view from the south shows damage to the North Augusta (Thirteenth Street) bridge following the August 1908 flood. The tracks and crossties dangled precariously after the trestlework collapsed. The cost of the repairs exceeded $2,000. The ladders were used by pedestrians until repairs were completed. (Courtesy of S. Marshall Sanders Jr., B-355.)

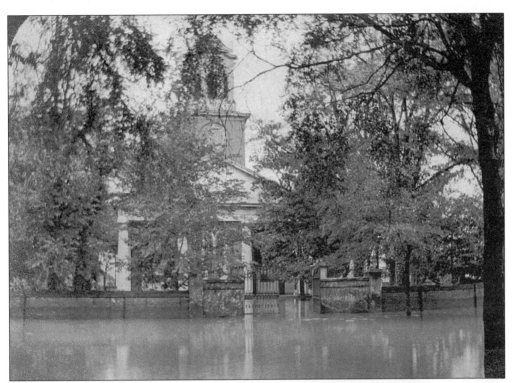

A slightly obscured but very wet St. Paul's Episcopal Church is seen in August 1908. St. Paul's was established in 1750, and is known as the "mother church" in Augusta. The first church building was situated next to Fort Augusta. This photograph is of the fourth church building. It was destroyed by the 1916 fire. (Courtesy of S. Marshall Sanders, B-409.) •

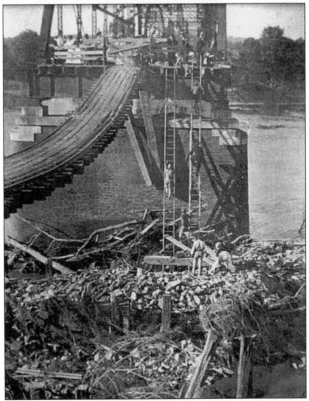

Another view shows the devastation to the North Augusta (Thirteenth Street) bridge caused by the August 1908 flood. The bridge was constructed in 1891 by the North Augusta Land Company to accommodate a trolley system and to stimulate development on the South Carolina side of the Savannah River. This bridge was replaced by the present structure in 1939. (Courtesy of Anne Lane, B-241.)

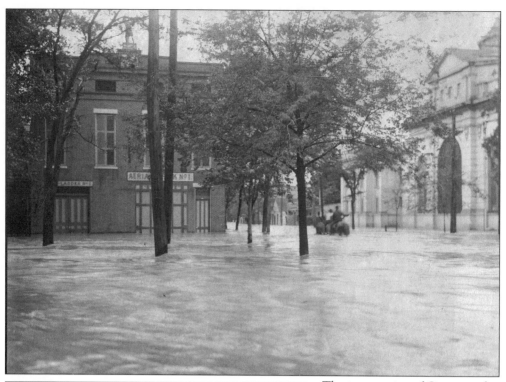

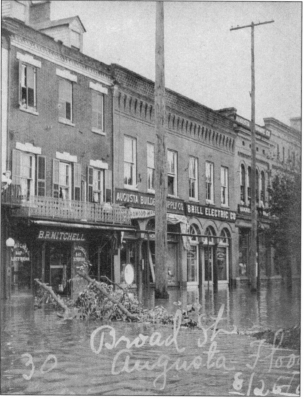

The intersection of Greene and Eighth Streets is pictured during the August 1908 flood. The building to the left (above) is the Augusta Fire Department's Hook and Ladder Company No. 1. The First Baptist Church is visible on the right. This is the second church building, constructed in 1902–1903. Its predecessor was the site of the first Southern Baptist Convention in May 1845. (Courtesy of Anne Lane, A-200.)

The north side of the 600 block of Broad Street is pictured during the August 1908 flood. The recognizable businesses are Brill Electric Company (641 Broad), Augusta Builders' Supply Company (643 Broad), and Burnell R. Mitchell Electric Supply Company (647 Broad). Electricity was introduced to Augusta in 1879. (Courtesy of S. Marshall Sanders Jr., B-292.)

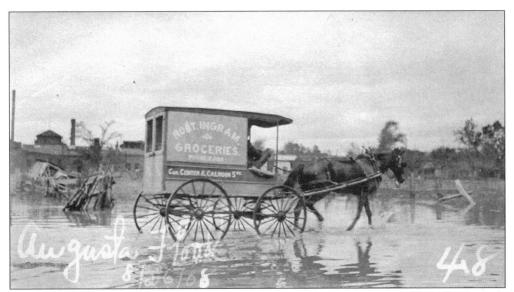

The delivery wagon of Robert Ingram, grocer, navigates the August 1908 floodwaters. Mr. Ingram's grocery store was located at the corner of Fifth and Calhoun Streets. Mr. Ingram lived above the store. (Courtesy of S. Marshall Sanders Jr., B-299.)

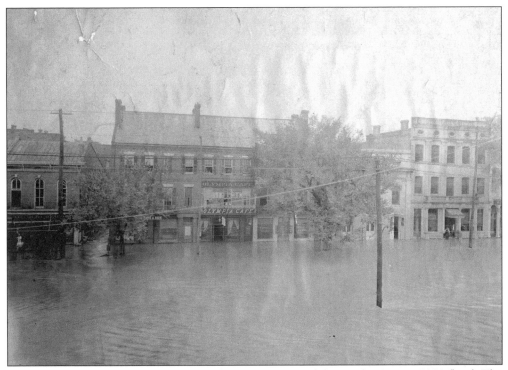

The north side of the 800 block of Broad Street is pictured during the August 1908 flood. The Olympia Café is noticeable in the center. (Courtesy of S. Marshall Sanders Jr., B-309.)

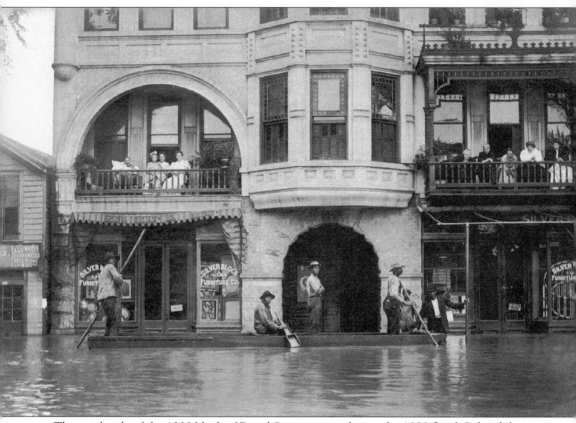

The north side of the 1200 block of Broad Street is seen during the 1908 flood. Behind the men in the boat is the Silver Block Furniture Company at 1231–1235 Broad Street. Thomas L. Sheats and William S. Halford owned the company at the time of the flood. (Courtesy of S. Marshall Sanders Jr., B-388.)

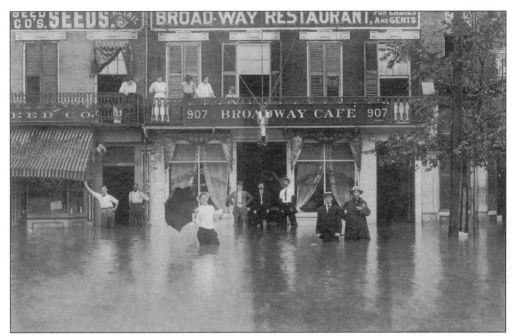

The Broadway Restaurant and Alexander Feed Company are pictured at 907 and 911 Broad Street after the 1908 flood. Mr. Henry G. Hastings was president of the seed company. (Courtesy of S. Marshall Sanders Jr., B-357.)

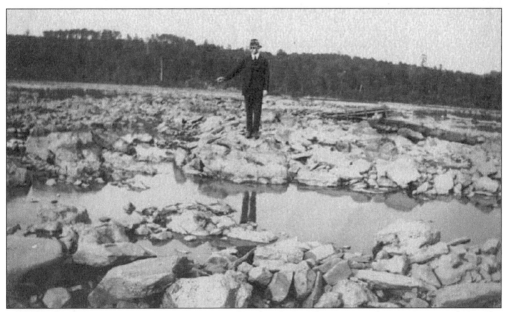

Though the Savannah River was prone to flooding, it is characterized near Augusta by rocky shallows, a transition from the Piedmont to the Coastal Plain section of the state. This easy crossing made the area attractive to Native Americans and later to European settlers. Charles G. Cordle, a noted professor at the Academy of Richmond County, Augusta Junior College, and Augusta College, is seen standing in a receded Savannah River in October of 1916. (Courtesy of Virginia Bowe Strickland, A-125.)

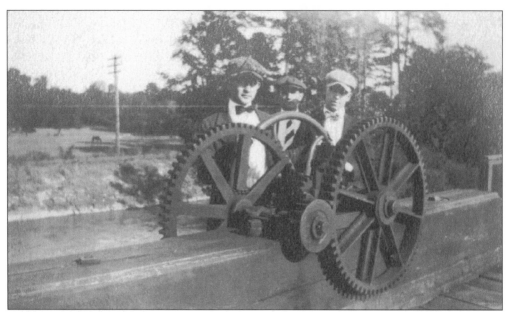

Charles G. Cordle (left) is standing behind gearworks used to open a gate on the Augusta Canal in September 1916. The Augusta Canal traces its conceptual origins to the 1830s and 1840s, when local business leaders resolved to establish Augusta as a manufacturing center. Henry H. Cumming foresaw the canal as the means of providing moving water to power factory turbines. Work on the canal began in 1845; water was let into it in November 1846. By 1850 two more levels were completed. The canal was enlarged using Chinese labor between 1872 and 1875. These improvements attracted several new textile mills. Today, the Augusta Canal is designated a National Heritage Area. (Courtesy of Virginia Bowe Strickland, A-124.)

The Savannah River is pictured below downtown Augusta, *c.* 1915. (Mrs. John T. Newman Jr., A-117.)

The Warwick Mill was located farthest up the canal of all the mills, and was constructed in 1882. It was later destroyed by fire. (Courtesy of Virginia Bowe Strickland, A-128a.)

The *Augusta* is seen at the city wharf, c. 1910. In 1816, the *Enterprise* became the first steamboat to arrive in Augusta, described in a contemporary newspaper account as moving "majestically along at a rate of 3 knots an hour against a strong current." By the 20th century, trains had replaced steamers as the preferred method of freight and passenger transportation. (Courtesy of Anne Lane, B-276.)

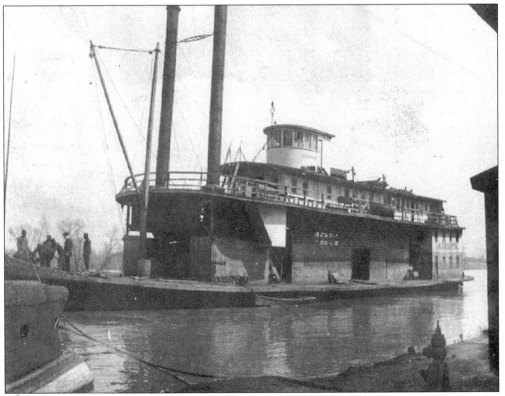

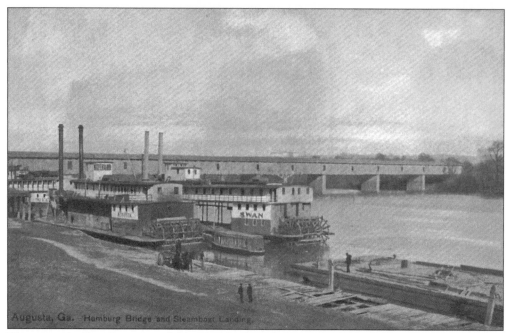

The sternwheelers *Augusta* and *Swan* moored at the city wharf. Steamboats began plying the Savannah in 1816. The Hamburg (Fifth Street) bridge is visible in the background in this image taken prior to 1908. It was damaged beyond repair by the August 1908 flood and replaced by a steel bridge. (Courtesy of Anne Lane, A-112.)

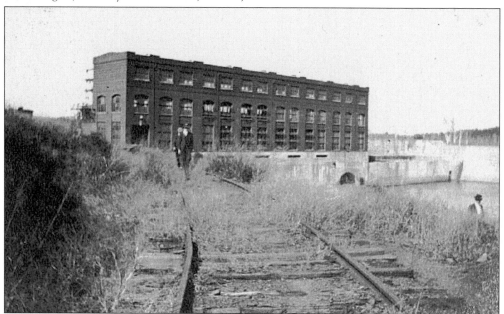

The Stevens Creek Power Plant is pictured on the Savannah River, October 1916. The plant, constructed by the Georgia-Carolina Power Company, began operation in February 1914. In its early years, the plant generated 40,000 horsepower. Mr. Franklin O. Brown, a New York businessman and Augusta winter resident, financed the project. (Courtesy of Virginia Bowe Strickland, A-126.)

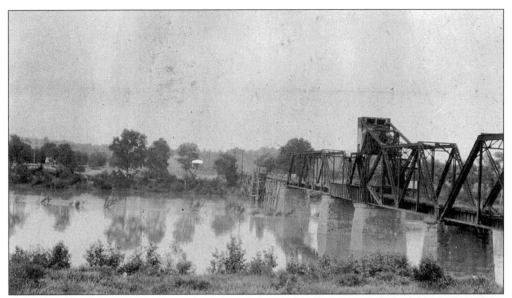

The Sixth Street railroad bridge is seen after the 1908 flood. A new draw span is evident. Note in the background remnants of the town of Hamburg, South Carolina. (Courtesy of Claud R. Caldwell, A-248.)

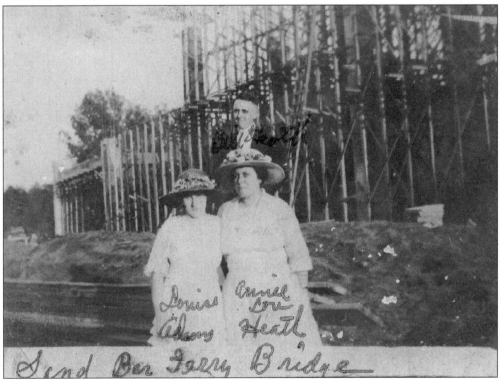

The Sand Bar Ferry Bridge is pictured under construction, c. 1923. Pictured from left to right are Louise Adams and Annie Lou Heath; Bill Heath is in the background. Formal opening ceremonies occurred in 1924. The structure replaced a ferry that for decades connected Beech Island, South Carolina, to Georgia. (Courtesy of Marie Kuhlke Ritch, A-162.)

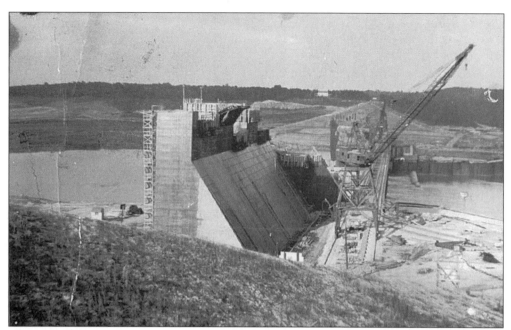

The Clark Hill project received congressional approval in 1944, and the dam is seen here under construction in 1950. It was authorized for flood control, improved navigation, the generation of hydroelectric power, and other purposes, including recreation. Clark Hill includes more than 1,100 miles of shoreline and extends upriver more than 39 miles. It has been referred to as "Georgia's inland ocean." (Courtesy of Donna Whaley, A-31b.)

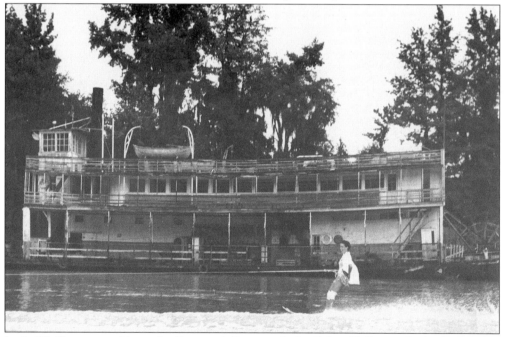

Janie W. Sims water-skis on the Savannah River with the *Robert E. Lee* in the background in August 1958. Ms. Sims attempted to set a world endurance record for the longest continuous water-skiing trip. (Courtesy of Janie W. Sims, B-174.)

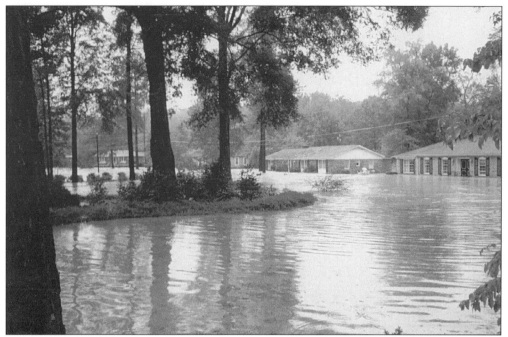

Floods and Augustans have coexisted for centuries. This is the Brynwood neighborhood after the October 1990 flood on Rae's Creek; it created a flood plain over one-half mile wide and damaged more than 170 homes. (Courtesy of Michael White, A-293.)

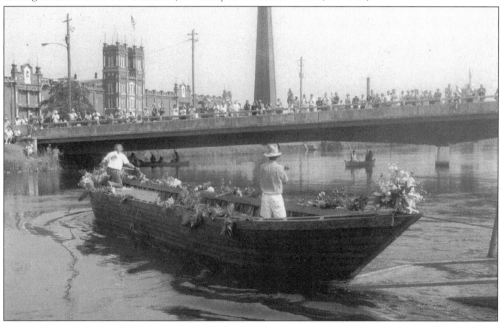

Pictured is the 1993 launching of *Fort Augusta*, a reconstruction of a Petersburg boat. Original Petersburg boats hauled cargo on the Savannah River, and later the Augusta Canal, during the 18th and 19th centuries. Captained by George Barrett, the reconstructed Petersburg boat's maiden voyage was an eight-day journey from Augusta to Savannah. The boat is now on exhibit at the Augusta Museum of History. (Courtesy of Howard A. Wilber, B-68.)

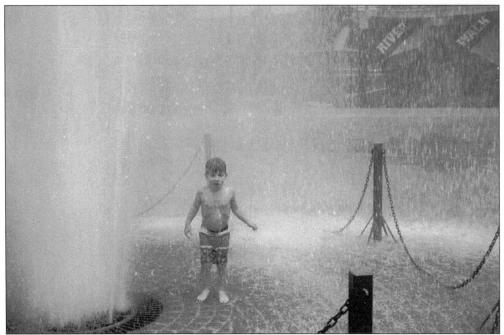

Brian Adams cools off at the fountain at Eighth Street and Riverwalk in July 1994. The fountain is a centerpiece of Riverwalk and the site of numerous community events each year. Riverwalk, dedicated in the 1980s, was a multi-million dollar revitalization project along the Savannah River that has breathed new life into downtown Augusta. (Courtesy of Linda Adams, B-53.)

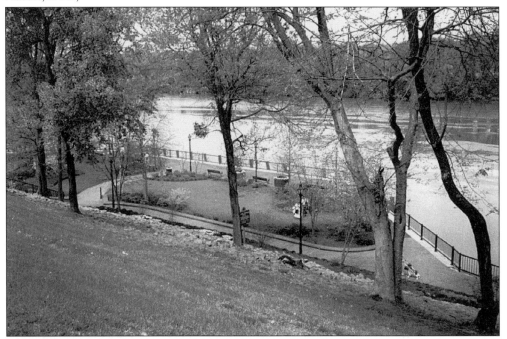

Riverwalk and the Eighth Street bulkhead are pictured on a beautiful spring day. (Courtesy of Edith Ogden, A-78.)

Six

BUSINESSES AND OCCUPATIONS

Unlike so many Southern cities and towns, Augusta moved towards economic diversification prior to the Civil War. The construction of the Augusta Canal in 1845 attracted several mills and factories in the latter half of the 19th century. Cotton was king for several decades as Augusta grew to become the second largest inland trading center of the commodity by the turn of the 20th century. Cotton was complemented by a full range of small businesses and financial institutions that lined both sides of Broad Street, making it the heart of Augusta's business district until the mid-1970s. Industrial growth, the growing medical facilities, the U.S. military at Fort Gordon, and the Savannah River Site have brought change and periods of prosperity to the local economy in the past 50 years.

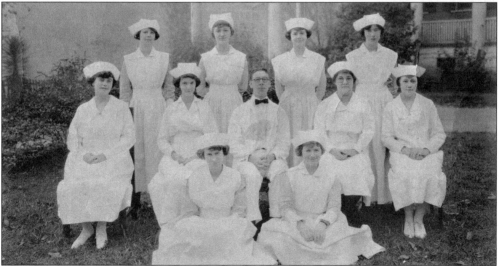

The Wilhenford Hospital Nursing School Class of 1924 is pictured here, with Loretta M. O'Leary seated at the far right and Jessie Porter standing second from left. Mrs. Grace Shaw Duff, a winter resident of Augusta, gave $30,000 to establish Wilhenford, Georgia's first children's hospital. The hospital opened in October 1910. (Courtesy of Catherine Cashin Nohe, A-102.)

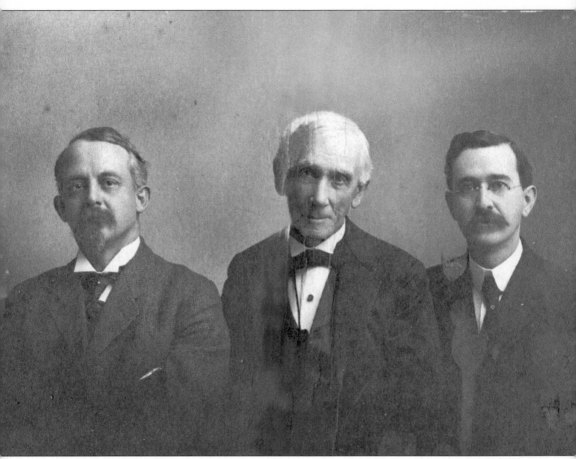

From left to right, W.H.T. Walker, Charles Estes, and Thomas J. O'Leary were photographed on the 25th anniversary of their employment with the John P. King Manufacturing Company in 1907. The three men began work with the company in 1882, the same year it began operations in Augusta. King Mill, formed by Mr. Estes and located on Goodrich Street, was the largest mill in Augusta. The company was named for the Georgia senator and president of the Georgia Railroad Bank. (Courtesy of Edward J. Cashin Jr., B-123.)

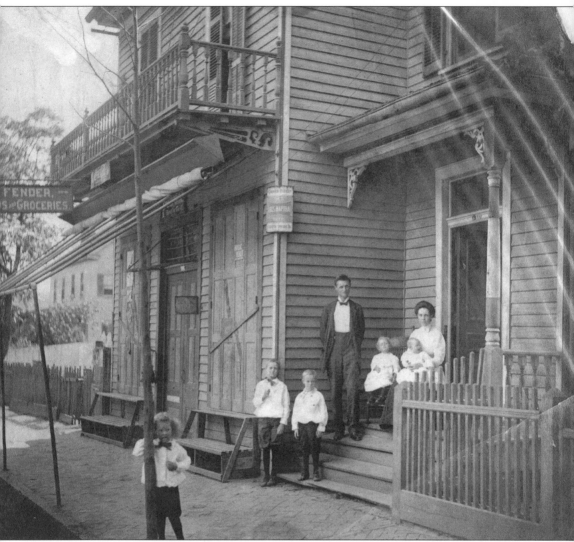

J.M. Fenders Goods & Groceries was located at 1219 Twelfth Street and is seen here in 1910. The Fender family (from left to right), Harold, John, Albert, Mr. John Fender, Tom, Mrs. Hattie Fender, and infant Beulah Mae, posed on the front porch of their home located adjacent to the store. Mr. Fender was one of nearly 300 retail grocers listed in the 1909 Augusta City Directory. (Courtesy of Richard H. Fender, B-192.)

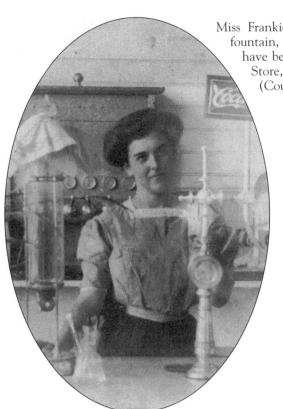

Miss Frankie T. Collins is seen operating a soda fountain, c. 1910. This photograph is believed to have been taken at the King and Hubbard Drug Store, which was located at 1286 Broad Street. (Courtesy of Milledge A. Murray, A-317.)

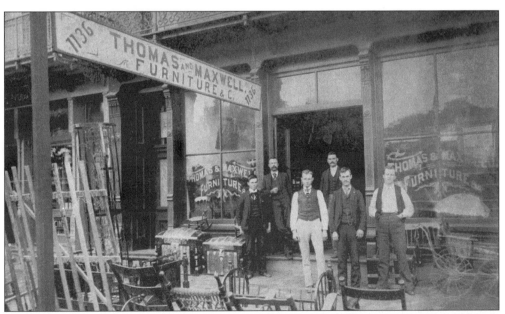

Thomas and Maxwell Furniture Store was located at 1136 Broad Street and is pictured here c. 1900. Alexander S. Thomas and Thomas R. Maxwell owned the store; Mr. Maxwell is seen on the left of the back row. At this time, more than a dozen retail furniture stores operated on or near Broad Street. (Courtesy of Kenneth Maxwell, B-157.)

Georgia Railroad Shops employees are pictured c. 1915. The shops were located on Eighth Street between Walker and Fenwick Streets, the present-day site of the U.S. Post Office. The Georgia legislature chartered the Georgia Railroad Company in December 1833 to stimulate economic activity. (Courtesy of Harriet Whaley, A-370.)

Marschalk's Grocers, located at the corner of Twelfth Street and Milledgeville Road, is pictured c. 1922. (Courtesy of Fred Marschalk, B-361.)

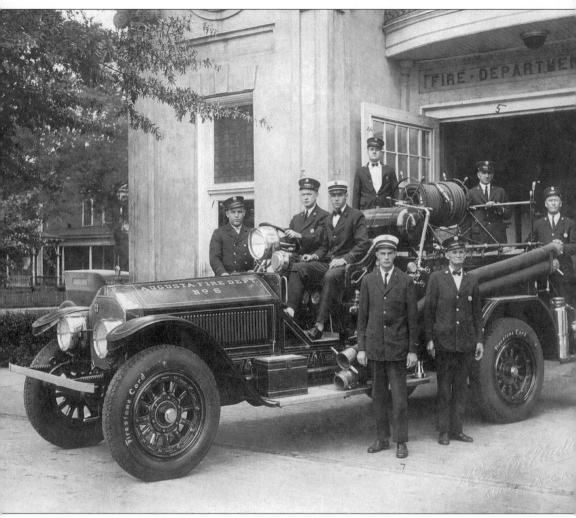

Engine Company Number Six of the Augusta Fire Department is seen here c. 1915. The building was located at the corner of May Avenue and Fifteenth Street. The firemen pictured, from left to right, are DeLong, Beard, Wren, Murphy, Inglett, Cliatt, and Roberts. (Courtesy of Tom Schneider, B-312.)

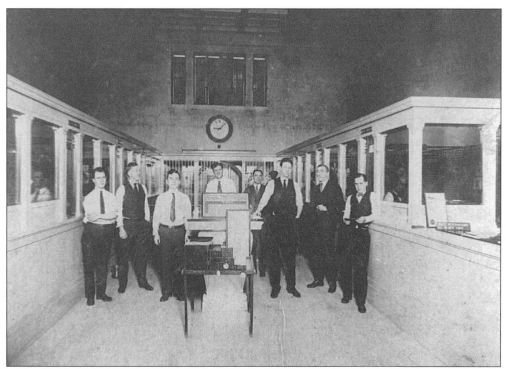

The National Exchange Bank was located at 823 Broad Street. The bank was chartered in Augusta in 1871, and the lobby and employees are pictured here c. 1920. (Courtesy of Milledge A. Murray, A-39.)

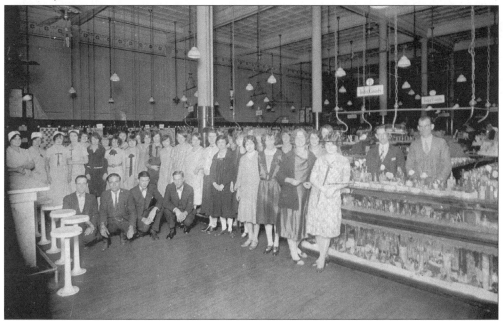

Sales clerks of the S.H. Kress and Company 5-and-10-cent store are pictured in 1922. The first Kress store was located in the 900 block of Broad Street. The store moved to the 800 block of Broad Street in the 1920s. (Courtesy of David A. Jones, B-71.)

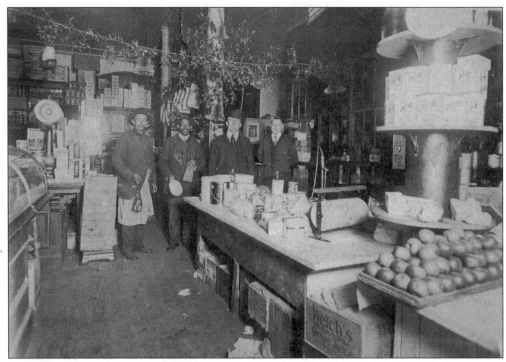

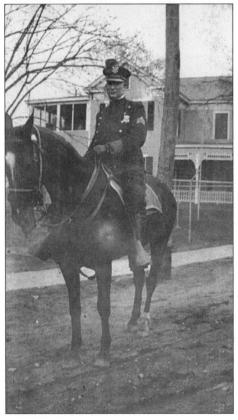

Seen here c. 1925, Hildebrandt's Grocery Store was founded in 1879 by German immigrant Nicholas Hildebrandt and was located at 226 Sixth Street. Identified in the photograph are Nathaniel Bates (second from left) and Nicholas Hildebrandt (far right, grandson of the founder). Today the store is operated in its same location by Nicholas's granddaughter Luanne Hildebrandt. (Courtesy of Althea B. Nash, B-375.)

City of Augusta police officer William Dunn is pictured c. 1930. (Courtesy of Harold Smith, B-130.)

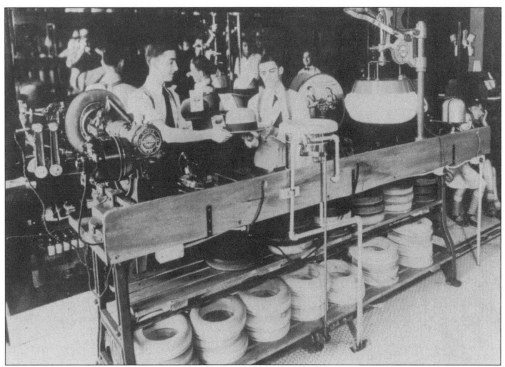

The interior of Paulos Brothers Hat Cleaners and Blockers at 317 Eighth Street is pictured c. 1938. Brothers Jonas and Peter Paulos operated a clothes cleaning and pressing business in the 200 block of Eighth Street in the 1920s. Demos, George, and Harry Paulos joined the family business in the 1930s. Pictured from left to right are Demos Paulos, George Paulos, and James Paulos (in the background). (Courtesy of Dianne Paulos Yost, A-342.)

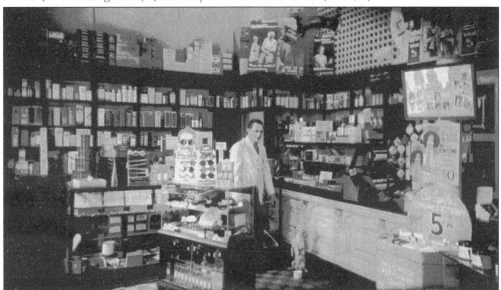

Proprietor LeRoy Gepfert is pictured inside the Gepfert Drug Company, c. 1940. Mr. Gepfert was one of nearly 30 retail druggists operating in Augusta at the time. He lived above his store, located at 1231 Broad Street. (Courtesy of Milledge A. Murray, B-86.)

Weaving Room employees are pictured at the Enterprise Manufacturing Company in 1932. Taking advantage of the enlarged Augusta Canal and state-mandated tax incentives, the textile company began construction of its large mill in 1877. It was the first large-scale textile mill to use the increased power of the canal. Following years of neglect and abandonment, Enterprise Mill was rehabilitated in the late 1990s by local businessman Clayton P. Boardman III. The mill is now home to residential, commercial, and retail spaces. (Courtesy of Katie Williams, B-197.)

Employees of Greene's Creamery and Greene's Drive-In and Restaurant are seen in this November 1944 photograph documenting the 30th anniversary of the creamery as well as the 10th anniversary of the restaurant. The family-owned and operated business was located in the 300 and 400 blocks of East Boundary. (Courtesy of Vicki Greene, A-94.)

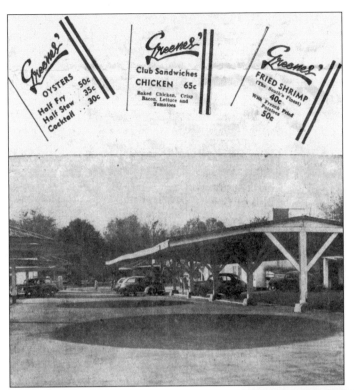

Greene's Drive-In, at 400 East Boundary, proclaimed to have the largest parking lot (100-car capacity) in the Southeast. Customers came for the renowned fried shrimp, and teenagers in particular enjoyed a malted drink called "The Thing." (Courtesy of Vicki Greene, A-95.)

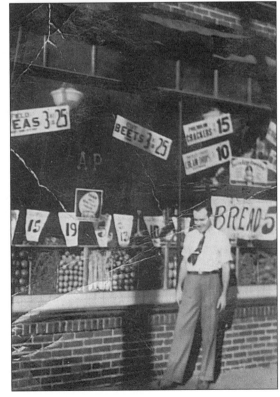

William T. Reese was the manager of this A&P grocery store c. 1940. This A&P branch was located at 1535 Walton Way, between Fifteenth Street and Chafee Avenue. Mr. Reese worked for A&P for 40 years. (Courtesy of Toby Reese, B-128.)

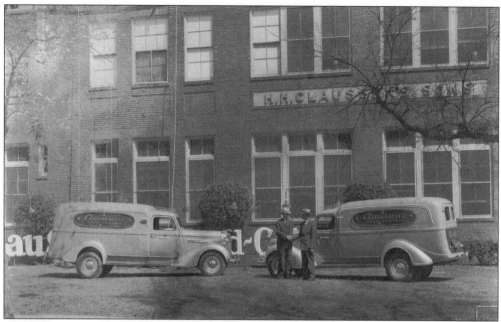

H.H. Claussen's Sons Bakery at 1589 Broad Street was constructed in 1917. J.C.H. Claussen established a bakery in Charleston, South Carolina, in 1841. In 1888, one of his sons, Henry H. Claussen, moved to Augusta to open a retail bakery and candy-making shop. The location of the original shop was at Broad and Tenth Streets. The construction of this large building at 1589 Broad signalled Claussen's entry into the wholesale baking market. (Courtesy of John A. Lotz, A-92.)

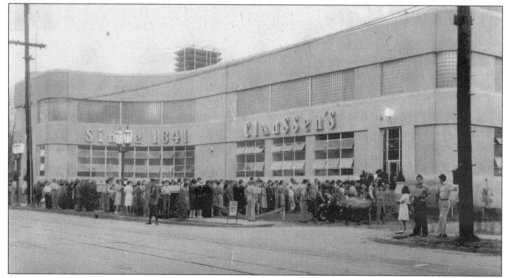

An open house and centennial celebration for Claussen's Sons Bakery was held in April 1941. This new building replaced the 1917 facility on the same site. It was one of four Claussen's plants located in South Carolina and Georgia. By this time, the company was managed by third- and fourth-generation family members George F. Claussen Sr., Euclid Claussen, and George F. Claussen Jr. Claussen's was famous for Buttermilk Maid bread and cakes. Today, the building houses a U-Haul storage facility. (Courtesy of John A. Lotz, A-93.)

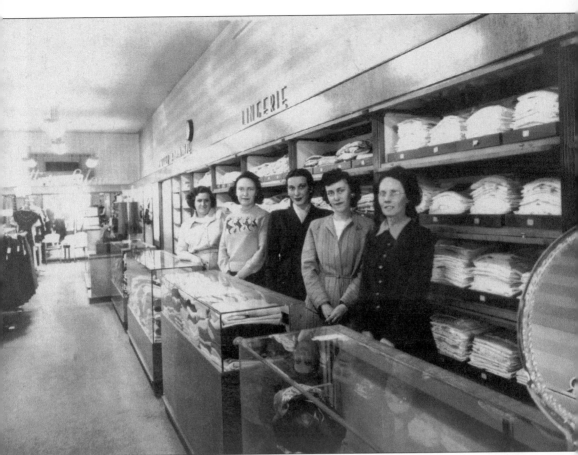

Mangel's opened in the late 1920s at 820 Broad Street, specializing in women's apparel. Pictured from left to right are the following sales clerks: unidentified, Virginia Griffith, Dorothy Nix, Lydia Griffith, and Thelmer Almand, *c.* 1945. (Courtesy of Doris A. Jones, A-75.)

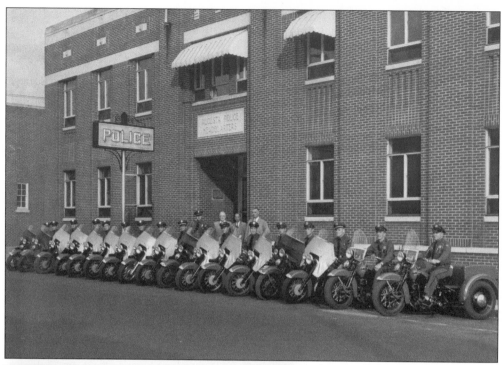

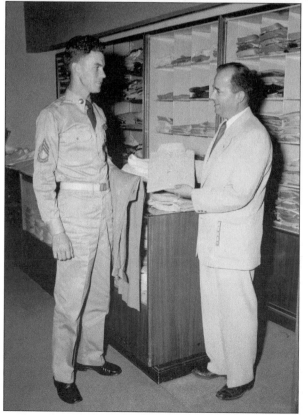

Augusta Police Department's traffic division is pictured in front of the department's building, c. 1950. The building occupied much of Ninth Street between Reynolds and Broad Streets, and a portion of it survives to this day. Officer Edward McGahee sits on the three-wheeler. (Courtesy of Kenneth McGahee, A-8.)

Sergeant First Class Walter K. Delk receives slacks and a sports shirt for being named Armed Forces Member of the Month, July 5, 1951. The award was sponsored by Cullum's Department Store, a Broad Street institution. The award is being given by A. Galphin Murray Jr., a longtime Cullum's employee. (Courtesy of Milledge A. Murray, B-89.)

Augusta Police Officer Frank H. Wall Jr. is pictured in the summer of 1958. Officer Wall was slain on November 18, 1958, in the 1300 block of Walton Way. The Monte Sano water tank is visible in the background. (Courtesy of Mrs. W. Henry Horton, A-347.)

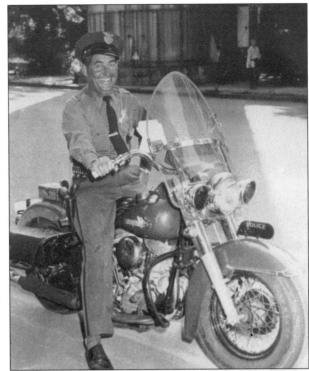

Mrs. Lillian B. Furman, switchboard operator at the Georgia Railroad Bank and Trust Company offices, is pictured c. 1960. (Courtesy Phyllis C. Holliday, A-179.)

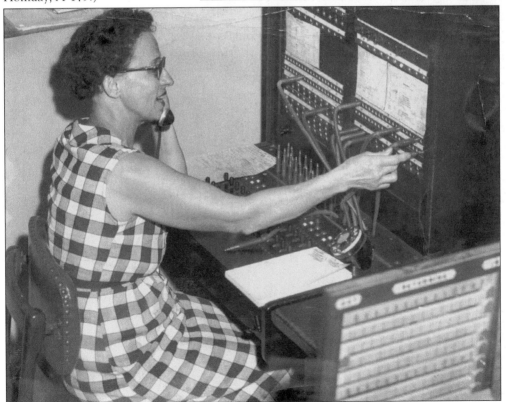

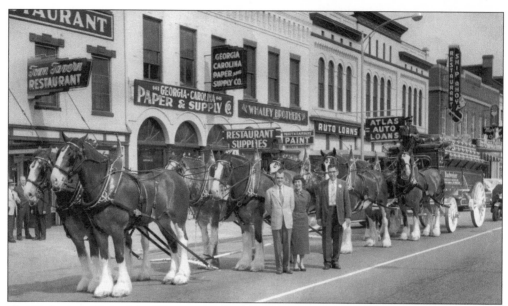

The Budweiser Clydesdales Team stopped on the northside of the 600 block of Broad Street, c. 1955. Pictured are Thomas Heffernan, Agnes Heffernan, and Timothy Heffernan, members of the family that owned the Town Tavern. The Town Tavern was located on Broad Street in the 1940s, 1950s, and early 1960s. It moved to Seventh Street in the mid-1960s, when the property in the 600 block was acquired to construct the Georgia Railroad Bank "skyscraper." The northside of the 600 block of Broad experienced little damage from the 1916 fire; consequently many historical architectural features are evident today. (Courtesy of Edward Heffernan, A-50.)

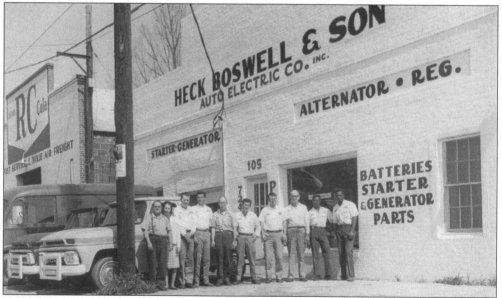

Heck Boswell & Son Auto Electric Company at 105 Sand Bar Ferry Road is pictured c. 1965. Pictured from left to right are Heck Boswell, Gail Folk, Ray Boswell, and Otis Mitchum (remaining persons are unidentified). Boswell's was in business for more than 60 years. (Courtesy of Penelope F. Boswell, B-367.)

Seven

MILITARY

The first military presence in the Augusta area was Fort Moore, built in 1715 near the present Sand Bar Ferry bridge. In 1736, Fort Augusta was constructed to protect the new settlement of the same name. During the Revolutionary War, the British occupation of Augusta ended with the fall of Fort Cornwallis in 1781. Augusta's most enduring military post, the Augusta Arsenal, was first constructed in 1821, and later dismantled and reconstructed on its present site in the city's Hill section. During the Civil War, the Confederate Powder Works contributed significantly to the war effort. During the Spanish-American War, two camps—Dyer (for black soldiers) and McKenzie—were established. Camp Hancock was constructed in 1917 and trained thousands of doughboys. In 1941, the U.S. Army began building Camp Gordon. Redesignated in 1956, Fort Gordon today is home to the U.S. Army Signal Corps.

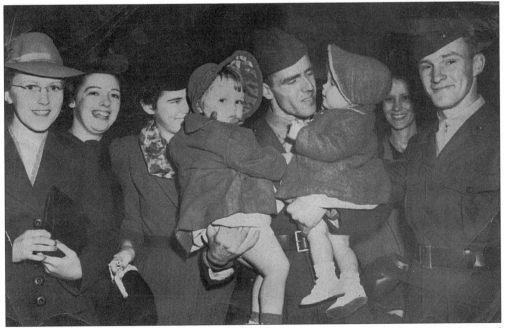

Marine reserves called to active duty gathered with family members at Union Station. Pictured from left to right are Harriet Whaley, Ellen Simpson, Mabel Hickman, Mary Ann Whaley (child), Theodore Hickman, Ellen Whaley (child), Irene Pucket, and Malcolm Whaley. (Courtesy of Harriet Whaley, A-372.)

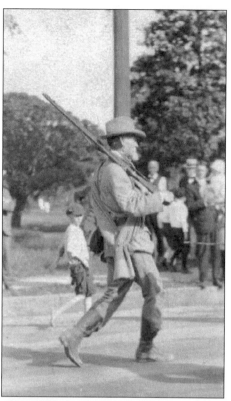

Civil War veteran Berry Benson marched in Augusta's 1917 Confederate Memorial Day parade on Broad Street. Sergeant Benson was a Confederate scout and sharpshooter, twice captured and twice escaped from Union forces. (Courtesy of Virginia Bowe Strickland, A-131.)

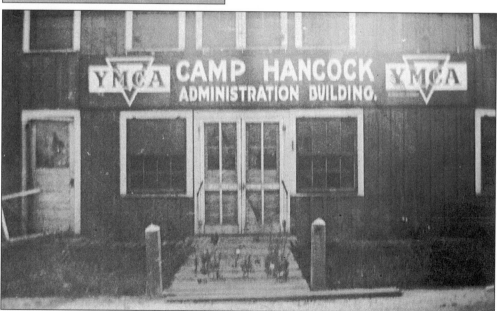

Camp Hancock was established in 1917 to address the need for WWI-era military training facilities. To entice the Federal government to select Augusta, the city provided the barracks and water at a cost of $35,000. The camp was named in honor of Union Major General Winfield Scott Hancock, and was located on the site of present-day Daniel Field. (Courtesy of Bob Richards, B-329.)

The Camp Hancock Mess Shack is pictured c. 1918. (Courtesy of Bob Richards, B-328.)

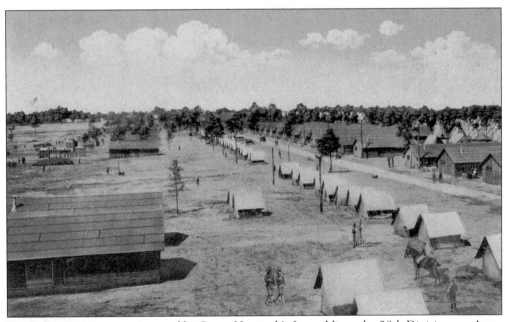

Pennsylvania Avenue was named by Camp Hancock's first soldiers, the 28th Division, an Army National Guard unit from the Quaker State, to remind them of home. The 28th Division left for France in late April and early May 1918. (Courtesy of the Augusta Museum of History, M-1.)

The Ordnance School opened in 1918, ultimately adding another 15,000 soldiers to Camp Hancock. (Courtesy of the Augusta Museum of History, M-2.)

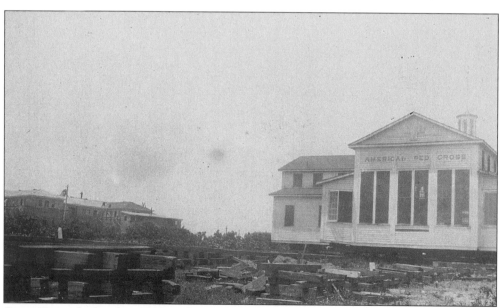

Camp Hancock closed in 1919, and remained U.S. Army property until purchased by the city of Augusta in 1927. The camp's Red Cross building was moved to the Lenwood Hospital campus in the early 1920s. (Courtesy of Virginia Bowe Strickland, A-216.)

Soldiers from Company D, 1st Georgia Infantry, Georgia National Guard, enjoyed a light moment at Wheless Station, *c.* 1917. Wheless Station was located near present-day Highland Avenue and Gordon Highway. (Courtesy of Joseph M. Lee III, B-164.)

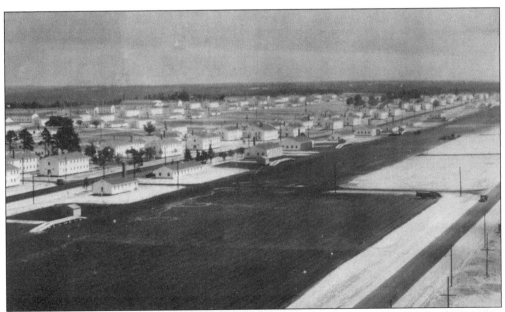

Camp Gordon was established in 1941 and was named for Lieutenant General John B. Gordon, Confederate States of America. The famed 4th Infantry Division, whose troops were the first on the Normandy beachheads, took combat training at Camp Gordon. (Courtesy of the Augusta Museum of History, M-3.)

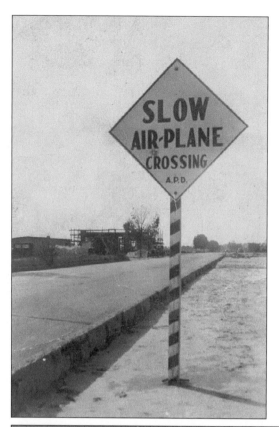

Motorists had to contend with airplanes crossing Wrightsboro Road at Daniel Field. The hangars were located on Wrightsboro Road's north side, across the street from the runways. This section of the road was closed when Daniel Field was in Army Air Corps service. (Courtesy of Joseph M. Lee III, B-167.)

Five-month-old Rosamond E. Bentley purchases a war bond from Colonel James W. Moss, Daniel Field's commanding officer, in June 1944. Miss Bentley's mother and William H. Cartledge (left) watch with approval. War bond drives were conducted throughout the war to generate revenue. (Courtesy of Rosamond Bentley, B-149.)

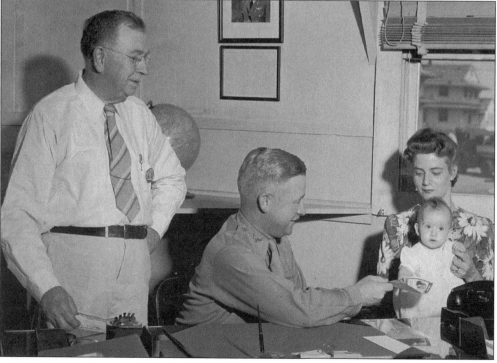

Colonel Cornelius E. O'Connor, Daniel Field Base commander (left), is pictured with Corporal Johnny Russian, a member of the base's 1944 baseball team who also played for the Augusta Tigers. During World War II, Daniel Field was an Army Air Corps base. (Courtesy of Rosamond Bentley, B-150.)

This is the gate one entrance to the Augusta Arsenal. The Arsenal geared up for production during World War II, employing as many as 1,800 people at the height of activity. Work at the Arsenal was concentrated on rebuilding or overhauling 70 different types of weapons and other equipment. (Courtesy of Joseph M. Lee III, B-162.)

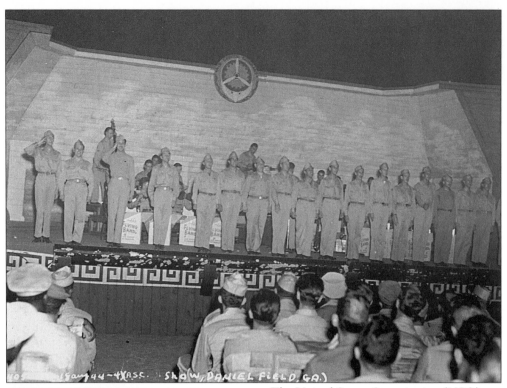

The United States Organization (USO) was responsible for providing entertainment to the troops. This performance occurred at Daniel Field in August 1944. (Courtesy of Rosamond Bentley, B-144.)

Soldiers were a common sight on Broad Street during World War II. Movie theaters, restaurants, department stores, and the local girls were the main attractions. Stimp Moore (left), Genevieve Rice, and Charles Royal enjoyed a day in downtown Augusta. (Courtesy of Charles C. Royal, A-47.)

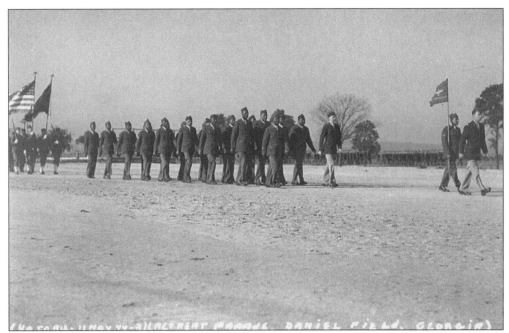

Troops were segregated by race during World War II. These African-American soldiers are marching in a November 1944 parade at Daniel Field. (Courtesy of Rosamond Bentley, B-154.)

Broad Street has hosted many parades. On numerous occasions, Augustans have expressed their gratitude to WWII servicemen and women. (Courtesy of Nancy Lutes, A-297.)

Major General Walter B. Richardson, Fort Gordon's commanding general, and Augusta Mayor George A. Sancken Jr. inspected the simulated Vietnamese village of An Khe at Fort Gordon in 1966. The village was used to train Fort Gordon troops for duty in southeast Asia. (Courtesy of Charlotte D. Barrett, B-258.)

In December 1966, Augusta community leaders, from left to right, Elias Burton, Mayor George A. Sancken Jr., Reverend C.S. Horne, Louis Harris, Bennett Brown, J.H. Ruffin, Sam Strauss, Millard Beckum, and Sherman Drawdy received a weapons lesson from U.S. Army Major Douglas Horne. By this time, Fort Gordon was home to the Army's Southeastern Signal and Military Police schools. (Courtesy of Charlotte D. Barrett, B-261.)

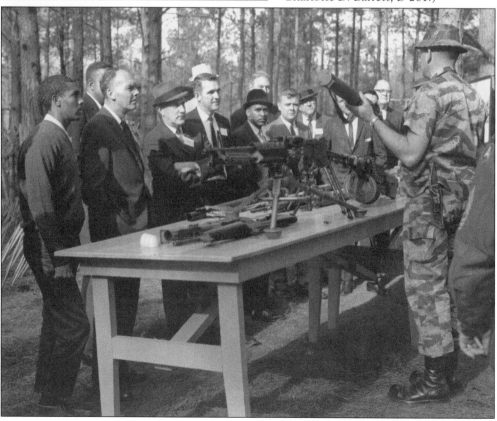

Eight
RESIDENCES

Homes of Augustans take many forms, and the photographs in this section depict their variety in scale, circumstance, and relative prosperity. From single-family mansions on Greene Street and in Summerville, to modest shotgun houses and quadplexes in Harrisburg and Frog Hollow, Augusta has examples of every style and house type since the 1790s. In addition, shown herein are several less conventional forms of housing that were constructed in Augusta including an apartment house, the Widows' Home, and even the Jail House. All of these have a place in the story of how Augustans lived in the 20th century, and help to illustrate our diverse backgrounds and circumstances that make us part of a unique community.

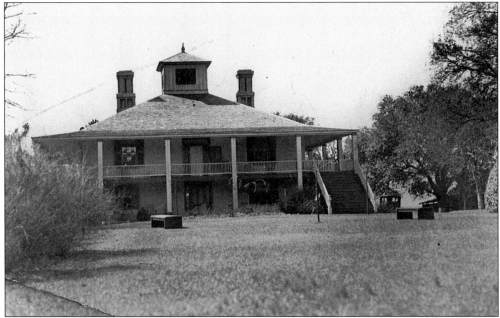

Augusta's most famous residence, known around the world, is the old Berckmans Plantation House at 2604 Washington Road. Built in 1853 by Dennis Redmond, a noted horticulturist, it was sold to Louis Berckmans in 1858 and continued as the home of his family, and the center of a famous nursery called Fruitland, until 1930. In that year, Bobby Jones, the famous golfer, selected the old nursery to become the Augusta National Golf Club, home of The Masters golf tournament. (Courtesy of Historic Augusta, Inc., H-1.)

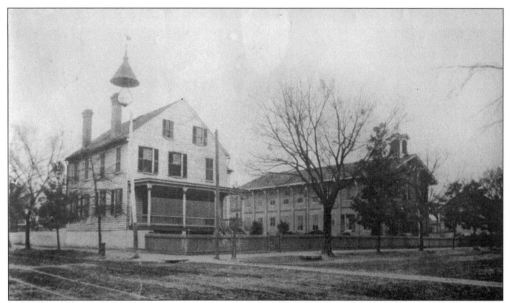

In 1898, Sacred Heart Catholic Church was constructed on this site, removing the *c.* 1820 house on the left. The church bought the property in 1874 from the McKinne family heirs, for whom Thirteenth Street had originally been named. The original church to the right is still standing, and was restored by the Knox Foundation for the use of the American Red Cross in 1998. (Courtesy of Historic Augusta, Inc., H-2.)

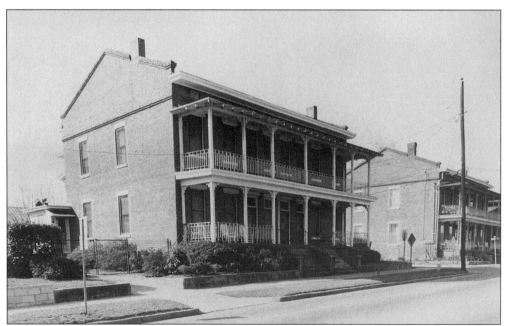

The Augusta Canal provided many jobs in Augusta in the 19th and 20th centuries. Mill villages were built to house the workers in close proximity to the cotton mills so that they could walk to work. Some mill housing was built to accommodate more than one family, including these two quadplexes at 1642–1648 and 1652–1658 Broad Street. (Courtesy of Historic Augusta, Inc., H-3.)

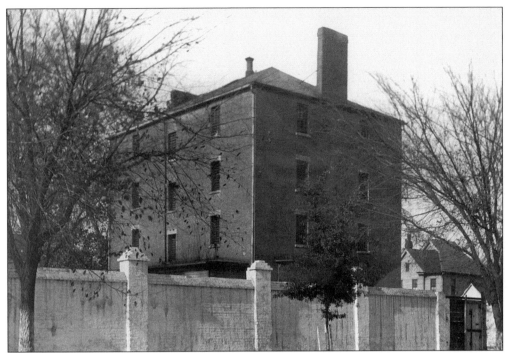

When Augustans ran afoul of the law, they were sent to live temporarily in the jail house, located at 406 Watkins Street at the southwest corner of Fourth Street. This 19th-century building served as the Richmond County Jail until 1938, when it was demolished to make room for a new structure. (Courtesy of Historic Augusta, Inc., H-4.)

Many mill workers lived in single family residences, including shotgun houses such as these. Shotguns are narrow houses with gabled roofs, and are one room wide and two to four rooms deep. They were generally built in rows, such as those shown above. Shotgun houses can be found in the Harrisburg and Bethlehem neighborhoods, and are also scattered throughout Augusta's many working-class neighborhoods. (Courtesy of Historic Augusta, Inc., H-5.)

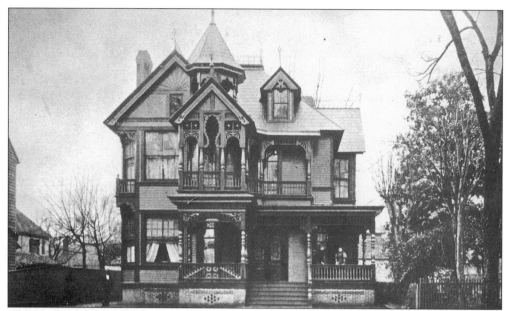

The home of Marcellus P. Foster was located at 446 Bay Street. When the Savannah River levee was built between 1913 and 1918, most of the residences and other buildings along it were sacrificed, including this one. The levee was built in response to the many floods that had devastated downtown Augusta over the years. The 1908 flood was the one that finally led to the levee's construction. (Courtesy Historic Augusta, Inc., H-6.)

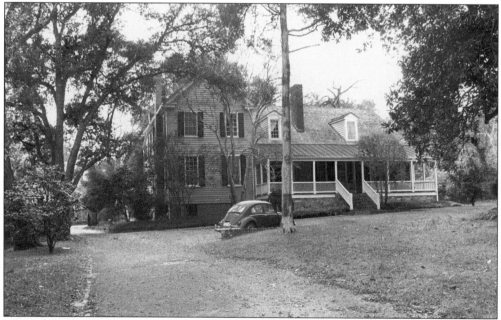

Floods and fires chased many people to the Hill, especially after the electric street railway was constructed in 1890, making it easier to climb. Summer cottages had been located there since the early 19th century, including this one at 2150 Battle Row. The original part of the house was built by John Cashin, but it was the summer home of the Harper family for many years. (Courtesy of Historic Augusta, Inc, H-7.)

The 20th century witnessed many families' flights from downtown Augusta, and adaptive use of the old mansions became the rule. This c. 1885 example of the Second Empire style at 938 Greene Street was the home of wholesale grocer William Bussey. In 1984 it became the Ronald McDonald House, where the families of critically ill hospitalized children from out-of-town stay for a very nominal rate. (Courtesy of Historic Augusta, Inc., H-8.)

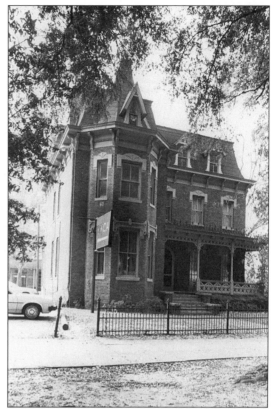

The Confederate Widows' Home replaced the old City Hospital in 1869 at 124 Greene Street. The building pictured below was constructed there in 1887 and provided a very dignified place for indigent widows of Confederate veterans to live. By the end of the 20th century, though Confederate widows had become extinct, the home continued to provide a safe and comfortable home for elderly indigent women. (Courtesy of Historic Augusta, Inc., H-9.)

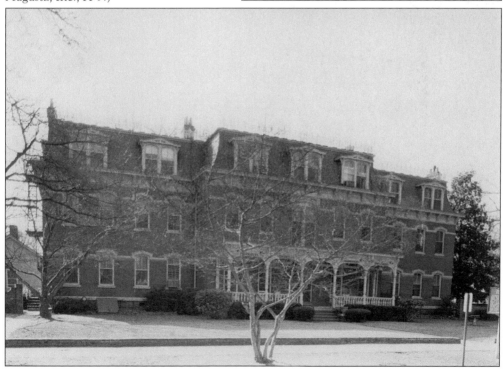

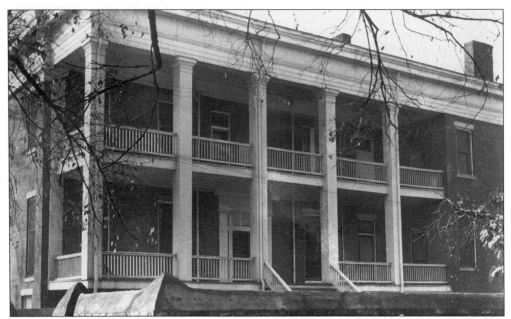

Another grand mansion on Greene Street that did not survive the 20th century was built by Turner Clanton in about 1850 at 503 Greene Street. This photo shows the back of the house. It was adaptively converted into the Richmond County Health Department *c.* 1935, and was demolished in the mid-1950s. A high-rise office building was constructed on its site. (Courtesy of Historic Augusta, Inc., H-10.)

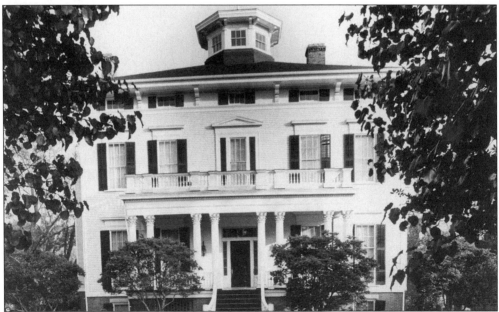

The Artemas Gould House was built as a summer residence at 828 Milledge Road *c.* 1861 for the family of a wealthy Augusta merchant. It was converted into a school and boarding house in the 20th century. Between 1967 and 1971, as a project of fledgling Historic Augusta, Inc., it was purchased by a group of investors, and converted into condominiums. (Courtesy of Historic Augusta, Inc., H-11.)

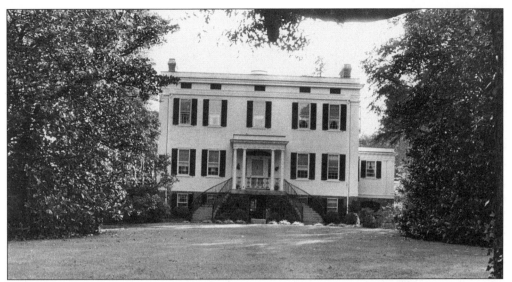

Although a product of the 18th century, this fine mansion was originally located at the southwest corner of Seventh and Greene Streets in downtown Augusta. It went through many owners and several remodelings before it came into the hands of Dr. A.J. Kilpatrick in the early 20th century. When Dr. Kilpatrick suggested to his wife that they should move to the new Forrest Hills development on the Hill, she refused to go without her house, where she had grown up. Consequently, it was moved to 1314 Comfort Road, piece by piece, and reconstructed on the site in 1929. (Courtesy of Historic Augusta, Inc., H-12.)

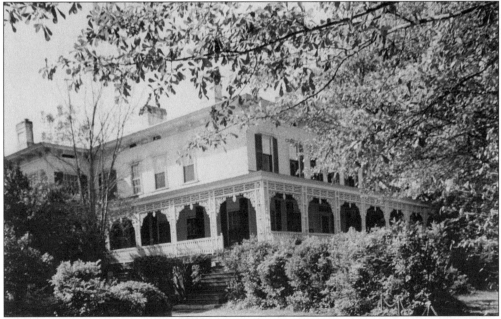

This mansion at 2248 Cumming Road was built in the 1820s by the Reid family and was remodeled about 1852 by Charles Jones Jenkins, governor of Georgia following the Civil War. Mr. Henry P. Crowell of Quaker Oats acquired it in the 20th century. Mr. Crowell developed extensive gardens around the house that were featured in garden tours of the 1930s. (Courtesy of Historic Augusta, Inc., H-13.)

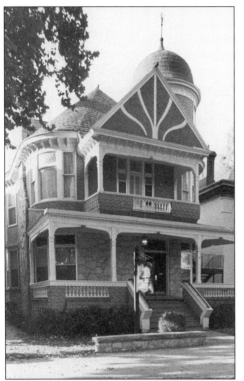

Charles D. Carr built this house at 406 Greene Street *c.* 1892. Its Queen Anne style is one of the high Victorian expressions characteristic of the residential sections of downtown Augusta. Located in the Olde Town neighborhood, it was opened as a bed-and-breakfast inn in 2000. (Courtesy of Historic Augusta, Inc., H-14.)

After Augusta had become a popular destination for winter tourists following the erection of the first Bon Aire Hotel in 1889, some of the wealthy Northern visitors decided to make permanent winter homes on the Hill. This was all a bit ironic, since the official name for the Hill was Summerville, reflecting its original development for wealthy Southerners seeking a cooler place to spend their summers. This house at 704 Milledge Road was built *c.* 1910 for George R. Stearns, and was designed by Augusta's premier and flamboyant architect of the early 20th century, Henry Ten Eyk Wendell. It once was the home of noted author Edison Marshall. (Courtesy of Historic Augusta, Inc., H-15.)

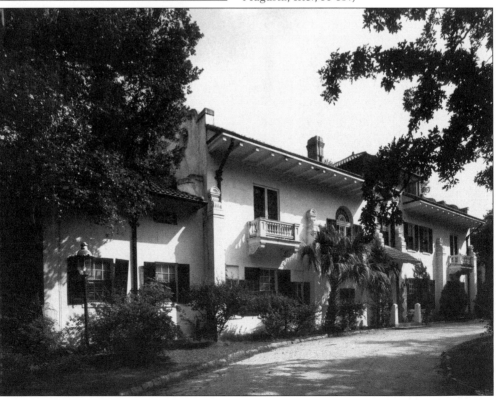

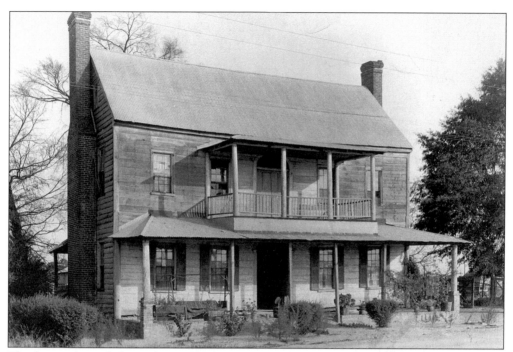

This house, formerly located on Old Savannah Road near Rocky Creek, was reputed to be the residence of General William Glascock, and the site where President George Washington was greeted by the official delegation of Augusta dignitaries in 1791, before they escorted him into town. It was demolished in the mid-20th century. (Courtesy of Historic Augusta, Inc., H-16.)

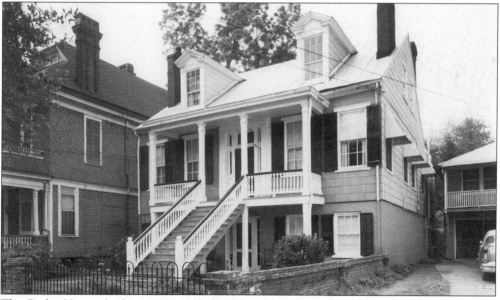

The Brahe House, built in 1850, is believed to have been the first house in Augusta with electricity when it became available. The Brahes occupied the home for 118 years, and in 1968 it was deeded to the Augusta Museum to be converted into a house museum. This project did not fully materialize however, and the home was converted to offices by 1990. (Courtesy of Historic Augusta, Inc., H-17.)

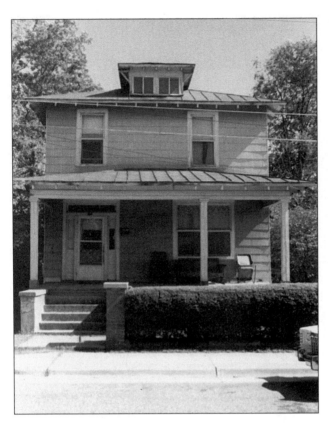

Lucy Craft Laney, a noted Augusta educator of African-American students at Haines Normal and Industrial Institute, lived in this c. 1908 house at 1116 Phillips Street. It was restored in the 1990s by the Delta Sigma Theta Sorority, which converted it into a museum of African-American history, and added facilities for a small conference center and a teaching lab in the basement. (Courtesy of Historic Augusta, Inc., H-18.)

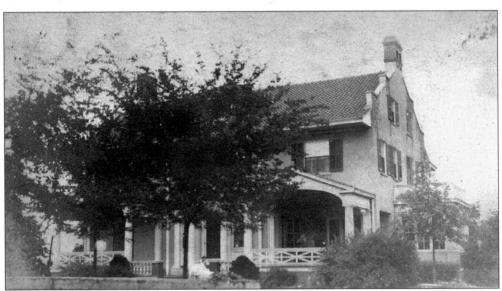

The family of Lula C. Maxwell, wife of T.R. Maxwell, lived in this house at 1306 Troup Street at the corner of Richmond Avenue, shown in this 1911 photo. Mrs. Maxwell died in 1948; her husband had been in the furniture business in downtown Augusta. (Courtesy of Kenneth Maxwell and the Maxwell family, B-158.)

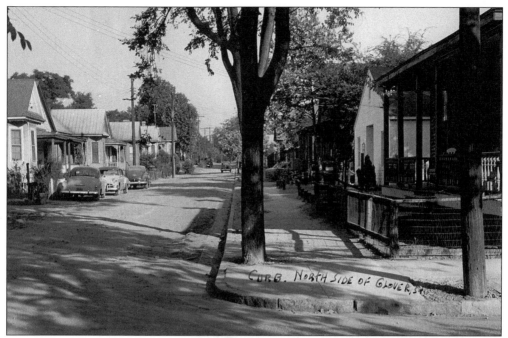

Frog Hollow was a neighborhood where the present University and Veterans Administration hospitals are now located. These houses, along Glover Street, are typical of those in the neighborhood, which were all removed in 1968 in a massive urban renewal project. This photo was taken in the 1950s. (Courtesy of Sarah N. Arnold, A-228.)

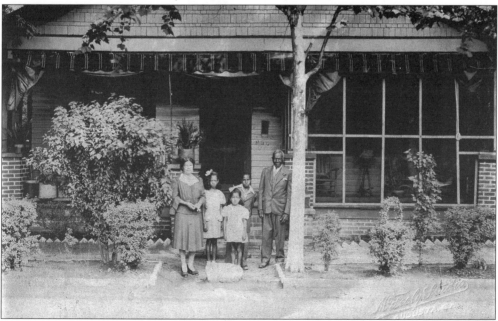

Amelia and Caesar Curry pose with their grandchildren at their home at 1150 Marks Street in this 1943 photo. The children, from left to right, are Ogretta and Bernia Dicks, and Benjamin Curry Mason. The Currys were lifelong members of Springfield Baptist Church, and excelled in education. (Courtesy of Richard Mason, A-155.)

Weekend getaways for Augustans in the early part of the 20th century were often nearby in the Georgia or South Carolina countryside. This cabin was built by Gwinn Nixon in the 1930s, and is located on the present campus of Augusta Technical Institute. The house was covered in the snow that hit Augusta in the winter of 1973. (Courtesy of Eleanora Hoernle, B-136.)

Fifteenth Street was lined with residences in the first half of the 20th century, as evidenced by this *c.* 1915 photo of 821 Fifteenth Street. This was the home of Dessey Landrum Kuhlke and his wife, Agnes Gray Kuhlke. (Courtesy of Marie Kuhlke Ritch, A-157.)

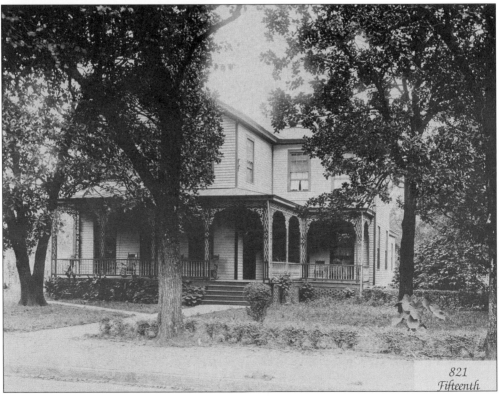

821 Fifteenth

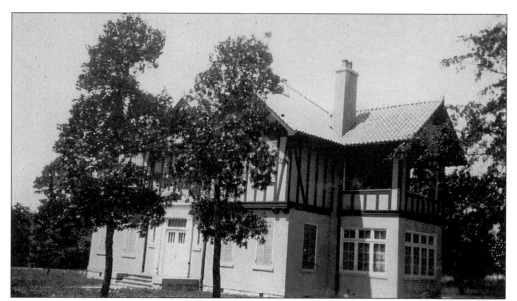

Mary Vason Phinizy had this half-timbered and stucco house constructed about 1922 by William F. Bowe Jr., a local contractor. It is located at 1107 Johns Road at the corner of McDowell Street. (Courtesy of Virginia B. Strickland, A-143.)

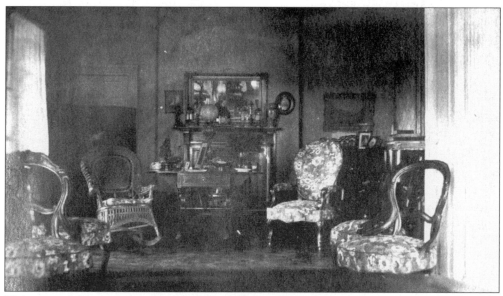

This view of the sitting room of the Nixon Home shows the conservative taste of early-20th-century Augustans. (Courtesy of Cobbs Nixon, B-59.)

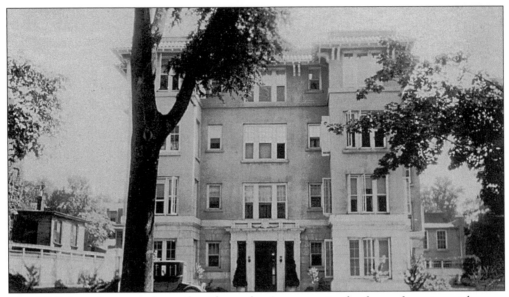

The 1910s brought a new form of residence for Augustans in the form of apartment houses. These structures were actually built as apartments, rather than being converted houses. Pictured in about 1922 are the Bowdre Apartments at 605 Greene Street at the northwest corner of Sixth. The apartments were built by contractor William F. Bowe Jr. as an investment for Bowdre Phinizy, publisher of the *Augusta Herald*. (Courtesy of Virginia B. Strickland, A-144b.)

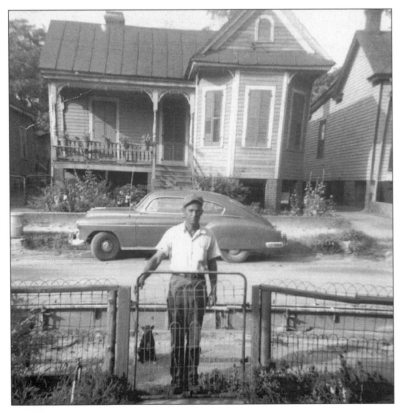

Mr. Columbus "Lum" Usry poses in front of his house on Glover Street in Frog Hollow *c.* 1950. (Courtesy of Annette Dobyne, B-102)

LIST OF SOURCES

Art Work of Augusta, Georgia. Augusta: W.H. Parrish and Company, 1894.

Augusta City Directories. Reese Library, Augusta State University.

Callahan, Helen. *Augusta: A Pictorial History.* Augusta: Richmond County Historical Society, 1998.

———. *Summerville: A Pictorial History.* Augusta: Richmond County Historical Society, 1993.

Cashin, Edward J. *The Story of Augusta.* Augusta: Richmond County Board of Education, 1980.

———. *The Quest: The History of Public Education in Richmond County.* Augusta: Richmond County Board of Education, 1985.

Collections. Richmond County Historical Society, Historic Augusta, Inc. and Augusta Museum of History.

Lee, Joseph M. III. *Augusta: A Postcard History.* Dover, NH: Arcadia Publishing, 1997.

Parker, Barry. *For the People: The Commitment Continues.* Augusta: University Hospital, 1993.

Reese's Cemetery Records, Reese Library, Augusta State University.

FOR FURTHER READING

Cashin, Edward J. *Old Springfield: Race and Religion in Augusta, Georgia*. Augusta: Springfield Village Park Foundation, Inc., 1995.

———. *General Sherman's Girl Friend and Other Stories about Augusta*. Augusta: Woodstone Press, 1992.

———. *The Story of Sacred Heart*. Augusta: Sacred Heart Cultural Center, 1987.

Corley, Florence Fleming. *Confederate City: Augusta, Georgia 1860–1865*. Columbia: South Carolina University Press, 1960. Reprint: Richmond County Historical Society, 1995.

Leslie, Kent Anderson. *Woman of Color, Daughter of Privilege: Amanda America Dickson, 1849–1893*. Athens: University of Georgia Press, 1995.

Torrence, Ridgely. *The Story of John Hope*. New York: Arno Press, 1969.

White, Michael C. *Down Rae's Creek: A Famous Stream at Augusta, Georgia's Fall Line Hills*. 1996.

Whites, LeeAnn. *The Civil War as a Crisis of Gender: Augusta, Georgia, 1860–1890*. Athens: University of Georgia Press, 1995.